IMAGES
of America

EAST GOSHEN
TOWNSHIP

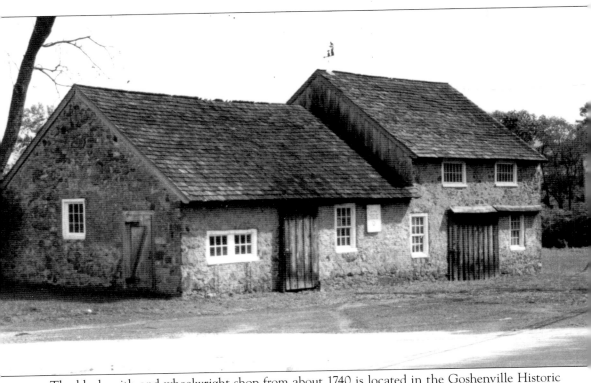

The blacksmith and wheelwright shop from about 1740 is located in the Goshenville Historic District at Route 352 and East Boot Road. It was operated as a wheelwright and blacksmith shop until 1939. The building remained empty for many years and was then used as a cattle shelter. In 1982, the building was restored and is now part of the township's museum and educational center. (East Goshen Township.)

On the cover: Taken in 1905 by J. Edgar Parker, this image is of the Goshen Friends Meeting House on Route 352. The building shown here was built in 1836 and enlarged in 1855. (Chester County Historical Society.)

IMAGES
of America

EAST GOSHEN TOWNSHIP

Linda M. Gordon

ARCADIA
PUBLISHING

Published by Arcadia Publishing
Charleston SC, Chicago IL, Portsmouth NH, San Francisco CA

Printed in the United States of America

Library of Congress Control Number: 2008935312

For all general information contact Arcadia Publishing at:
Telephone 843-853-2070
Fax 843-853-0044
E-mail sales@arcadiapublishing.com
For customer service and orders:
Toll-Free 1-888-313-2665

Visit us on the Internet at www.arcadiapublishing.com

*Dedicated to my husband Donald W. Barshinger
and to all those who have served East Goshen Township*

CONTENTS

ACKNOWLEDGMENTS

I wish to thank the following, for without their help, this book would not have been possible: Louis F. "Rick" Smith, township manager, for his help in identifying properties that are no longer here and for digging through township records for information on many of the properties and developments; the East Goshen Township staff for their patience and help with the research; Pamela Powell and the Chester County Historical Society (CCHS) for use of their photographs and assisting in the research for this book; Edward Lendrat for researching many of the properties to determine the dates of construction; Kathryn Yahraes for proofreading and editing the copy; and the East Goshen Historical Commission members for their support of this project.

Many thanks go to the following current and former residents for the use of their photographs: Anna Baldwin, Edward Bond, Lois Cahaley, John Chatley, Sarah Credeur, Diane Degnan, Saunders Dixon, Margie Ferguson, Raymond Freyberger, the Goshen Baptist Church, Edith Nields Green (deceased), Richard Hankin, Linda Hicks, Frank and Cathy Hoffman, Robin Hutchinson, William Keslick, Phyllis Marron, Richard Neff, Mary Ann Ninnis, Stephen Plummer, QVC, Benjamin Rohrbeck, Mae Schmitt, Ruth Ann Schultz, Virginia Shainline, Carroll Sinquett, SS. Peter and Paul Catholic Church, SS. Simon and Jude Catholic Church, Robert Stafford, Mrs. Bruner Strawbridge, Louise and George Velde Jr., Ruth Ann Harrison Weeks, John and Marty Windell, JoAnne Wright, Jack Yahraes, Steven Yost, and Patricia Youngblood.

All photographs identified as East Goshen Township were found in the township files, and the original source was not identified. Anyone with information on the source of these photographs, please contact the township.

Every effort has been made to properly identify the people and places in this book. Should any reader have information that corrects any errors or can identify the unidentified, please contact the East Goshen Township office at 1580 Paoli Pike, West Chester, Pennsylvania 19380.

INTRODUCTION

East Goshen Township was part of the original grant to William Penn in 1681. The early settlers named the area Goshenville or "the Land of Goshen." Two men, John ap Thomas and Edward Jones, bought 5,000 acres, representing themselves and 15 other families.

In 1704, Goshen Township was formally organized with Cadwaladen Ellis appointed the first constable. Goshen's acreage encompassed what are today East Goshen Township, West Goshen Township, and the borough of West Chester. In 1788, West Chester was incorporated as a borough. In 1817, Goshen was divided into East and West Goshen Townships.

The early settlers of Goshen were Quakers. As a predominately Quaker community, the Revolutionary War caused many divisions between families, neighbors, and friends. Many Friends, as Quakers are called, were "read out of the Meeting" for taking sides in the war.

On September 16, 1777, after the battle of the Brandywine, Lord William Howe, who was in charge of the British armies in the colonies, met with Lord Charles Cornwallis, Gen. James Grant, and others at the Goshen Friends Meeting House, presently near the intersection of Route 352 and Paoli Pike. After the meeting, Cornwallis led his troops a short distance north on Goshen Road (present-day Route 352) to encamp.

At around 1:00 p.m. on September 16, Cornwallis and his troops met Gen. George Washington's forces near what is today Greenhill Road. A skirmish took place, and Washington's troops were routed. At the same time on Boot Road, another skirmish took place between Howe's troops and the Pennsylvania militia. Fortunately for the Americans, a sudden, violent rainstorm hit the area, turning the roads into quagmires and dampening the gunpowder on both sides. This act of nature gave Washington the time necessary to retreat to Valley Forge.

East Goshen Township is approximately 10 square miles, and running through it are two main creeks, the Chester Creek and the Ridley Creek, plus numerous small tributaries. Due to the abundance of water there were 13 mills along the Chester and Ridley Creeks. The majority of them were grist- or sawmills. However, there were also cotton and woolen mills and one cider mill.

The first mill was built on the Chester Creek in 1740. It was a subscription mill owned by its stockholders and operated by George Ashbridge II. It was in operation until 1899 when it was sold to the Borough of West Chester. Between 1740 and 1800, three more mills were constructed, two on the Chester Creek and one on the Ridley Creek. From 1801 to 1881, eight more mills were constructed, one on the Chester Creek and seven on the Ridley Creek.

There were two main east–west roads between Philadelphia and East Goshen: State Road, known currently as Paoli Pike, and West Chester Pike. The main road going north and south was the Kings Highway, current-day Route 352. It was along these roads that goods were transported to Philadelphia.

The earliest record of a school in the township dates from 1760 when a subscription school was built on the Chester Creek south of Paoli Pike. In 1809, a new public school was built on what is today Sturbridge Lane to replace the Chester Creek School. That school was abandoned in 1851 after the schoolteacher, Rachel Sharpless, was murdered by 19-year-old George Pharoah as she was opening the school. In 1853, a new school was built on Route 352 just north of Strasburg Road and was known as the Rocky Hill School. It was replaced in 1879 when a crack was discovered in the foundation and could not be repaired. The building was sold in 1955 and is now a private residence.

On the north side of the township, the Ridge School was built sometime in the early 1800s on the property that is now Hershey's Mill Village. In 1854, the Maple Grove School was built on Greenhill Road to replace the Ridge School. That school was replaced in 1884 with a new building on the same site but set farther back from the road. In 1938, the building was sold and since then has been a private residence.

As the population grew, there was a need for another school. This school was located in Goshenville at Route 352 and Paoli Pike. Built in 1873, it was a two-story stone structure that operated until 1955. It is now the East Goshen Bible Church.

The last of the one-room schoolhouses to be built was the Goshen Heights School, constructed in 1916 on School Lane in the Goshen Heights neighborhood south of West Chester Pike. It was torn down in 1979.

In 1955, the three one-room schoolhouses were closed when the new East Goshen Elementary School was built on Route 352 south of Paoli Pike. The new school contained six classrooms. As the population of the township continued to increase, the school was enlarged several times. In 1961, five more classrooms, an all-purpose room, a health room, and a storage room were added. In 1964, two more classrooms were added, and in 1966, a new wing was added to increase the capacity to over 600 students. In 1995, the school was again enlarged with the addition of a new gymnasium, an art room, a music room, a science laboratory, and classrooms, which brought the total of classrooms to 27.

In 1949, the first Goshen Fair was held to raise money for the Goshen Fire Company, which was formed as a volunteer fire company in 1950. Charles "Dutch" Clark was the first fire chief. The only fatality in the history of the Goshen Fire Company occurred in 1955 when assistant fire chief George Parry died because the fire truck he was on rolled over on the old railroad bridge on Route 29. In October 2005, the township dedicated a new street as Parry Circle in his honor. Today the fire company has eight full-time and four part-time paid firefighters in addition to several volunteers

In 1983, the township joined with Westtown Township to form a regional police department that covers East Goshen Township, Westtown Township, and Thornbury Township. Today the police department has 40 full- and part-time police officers.

East Goshen Township is governed by an elected five-member board of supervisors who act as the administrative and legislative branch of government. In addition to the board of supervisors, the township has a planning commission, conservancy board, historical commission, park and recreation board, and municipal authority, which consists of citizen volunteers. The township currently has 16 administrative and 10 public works employees.

East Goshen Township was primarily an agricultural community through the 1960s. Today's employment base is dominated by managerial and professional occupations and has changed from a rural agricultural area into a suburban community.

East Goshen Township experienced rapid growth from the 1970s through the 1980s when the population went from 5,138 to 15,138. Where once there were farms, there are now residential subdivisions and corporate parks. However, the township parkland and open space along Paoli Pike still give one the feeling of times gone by. This growth from farmland to suburbia has changed the landscape. *East Goshen Township* is an attempt to document those changes and the township's history.

One

THE EARLY YEARS

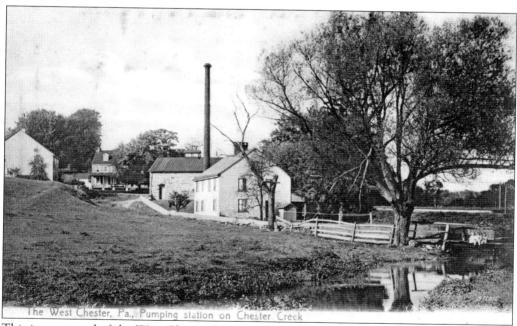

The West Chester, Pa., Pumping station on Chester Creek

This is a postcard of the West Chester Pumping Station built on the Chester Creek in 1897. In 1907, the estate of Christian Dutt and trustees of Westtown Friends Boarding School sued the Borough of West Chester for taking too much water from the Chester Creek. The jury awarded the plaintiffs $6,224 in damages. In 1923, the West Chester Water Works was constructed on this site. (East Goshen Township.)

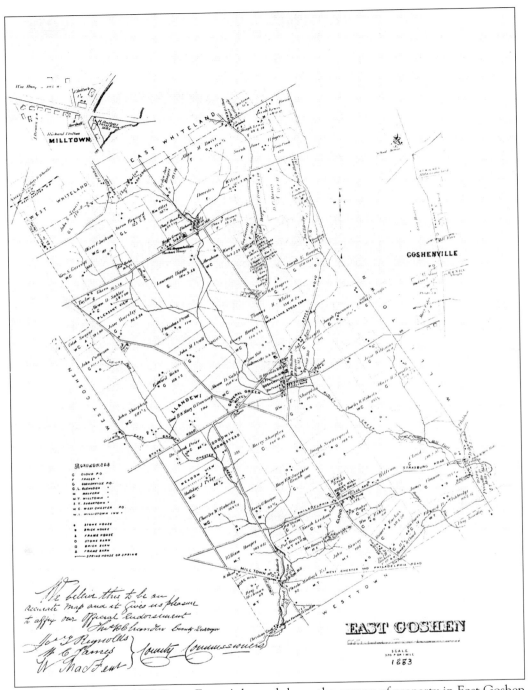

This map is from the 1883 Breou Farm Atlas and shows the owners of property in East Goshen Township. (East Goshen Township.)

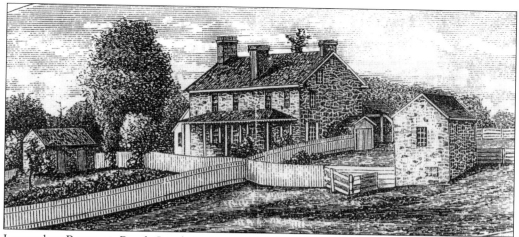

Located on Reservoir Road, Goodwin Acres is listed on the National Register of Historic Places. The above is an illustration of the house as it looked in 1840 from the 1881 *History of Chester County* by J. Smith Futhey and Gilbert Cope. The original part of the house was built in 1736 by Robert Roberts. Roberts sold the property to Thomas Goodwin in 1749. In 1803, an addition was made to the house by Richard and Lydia Goodwin. (Chester County Historical Society.)

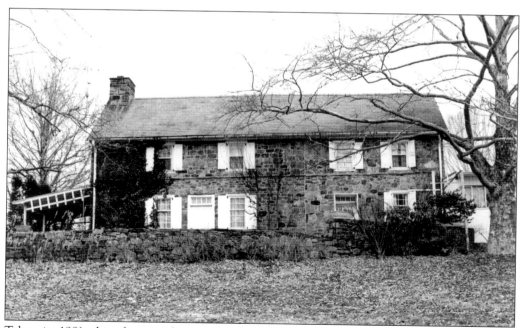

Taken in 1981, this photograph is of Goodwin Acres on Reservoir Road. Looking closely at the photograph, one can clearly identify the 1803 addition from the original 1736 portion of the house by the change in the pattern of the stone. (CCHS.)

This house is locally known as the c. 1727 Cornwallis house. In 1759, George Hoopes inherited the property from his father. Hoopes was involved in revolutionary activities prior to the American Revolution. It is ironic that in 1777 at the end of the battle of the Clouds, British lord general Charles Cornwallis assumed control of Hoopes's house to use as his headquarters. In 1911, the large picture window was installed, other windows were enlarged, and doors were replaced, making it ineligible for the National Register of Historic Places. (East Goshen Township.)

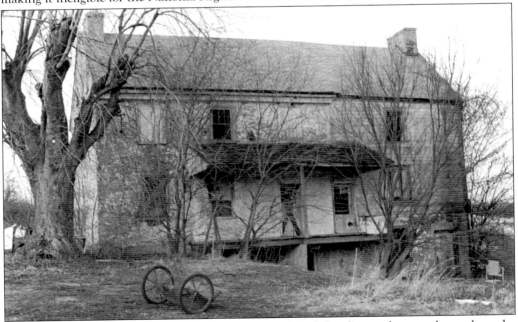

This photograph from 1981 is of an abandoned Colonial farmhouse that was located on the Malvern Golf Course. The date of construction is unknown. It appears on the 1883 Breou Farm Atlas on the property of Allen M. Davis. In the mid-1980s, the development of Lockwood Chase was built on the golf course and the house was torn down. (CCHS.)

Shown in a photograph taken in November 1951, the George Ashbridge house is located on East Strasburg Road. The date stone contains 1732 and the initials "GA," indicating that the original portion of the house was built by George Ashbridge II. Ashbridge was elected to the provincial assembly and represented Chester County from 1732 to 1772. Several additions have been made to the house over the years. (CCHS.)

Known locally as the *c.* 1750 Toll House and originally located on West Chester Pike, this small stone house was demolished in 1989 when the construction of Wagner's Carpet Store was approved for the site. (East Goshen Township.)

This illustration is from the 1881 *History of Chester County* by J. Smith Futhey and Gilbert Cope. In the late 1800s, the property was owned by Mary G. and Samuel R. Downing and was known as Llandewi as it is today. The house is located on Paoli Pike across from the Meadows development. (East Goshen Township.)

If the Downings were to return today, they would easily recognize their house because little has changed since they lived there in the late 1800s. However, the area around Llandewi farm has changed dramatically, and it is now surrounded by the Goshen Corporate Park on Paoli Pike. (East Goshen Township.)

The Three Tun Tavern was built in 1729 and is located at the corner of King Street and Route 352. While it has not yet been placed on the National Register of Historic Places, it is eligible because of its association with transportation. It served as a tavern during the 18th and 19th centuries and is an example of local, rural architecture. (East Goshen Township.)

This photograph from 1940 is of the Second Empire Victorian that replaced the original General Green Hotel and Tavern and was located on the northwest corner of Paoli Pike and Boot Road. It was torn down in 1955. The original tavern served as the headquarters of Gen. Nathanael Greene during the battle of the Clouds in September 1777 and thereafter was called the General Green. (CCHS.)

The Ellis Williams house was built in 1754 and is located on East Boot Road and is listed on the National Register of Historic Places. It represents a highly preserved example of Colonial architecture. The portion of the house on the left side in this photograph is a 1790 addition. (East Goshen Township.)

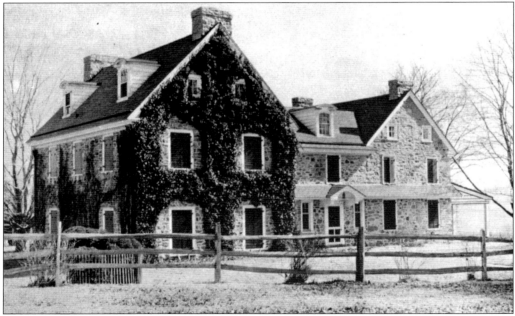

This was the main residence, built around 1750, on the 280-acre Applebrook farm at the time the land was sold in 1964. It is shown on the 1883 Breou Farm Atlas as being owned by John Passmore. It was torn down when Smith Kline and French Laboratories purchased the property for its animal health division. (East Goshen Township.)

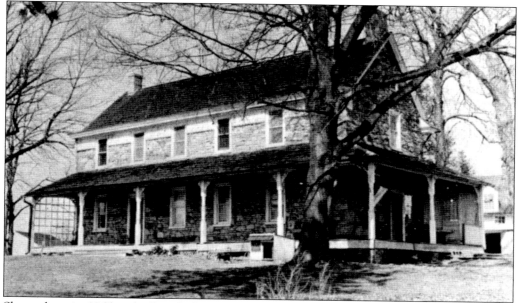

Shown here in 1965 is the Joseph Garrett house, which was built around 1725 and located on Paoli Pike. In the late 1800s or early 1900s, a large addition was put on the western end of the building. A fire in the late 1960s destroyed much of the interior of the addition, and the house sat vacant until 2001 when the Chester County Chamber of Business and Industry restored and renovated it for its headquarters. (East Goshen Township.)

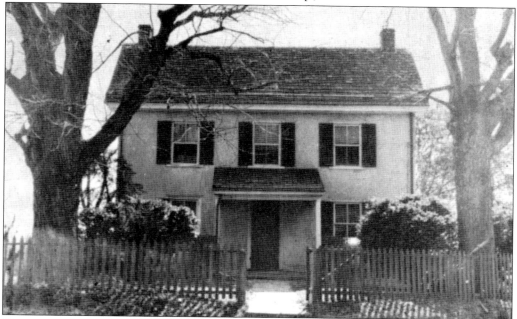

This tenant house, built around 1845, was originally located on Paoli Pike across from Taylor Avenue. It is shown on the 1883 Breou Farm Atlas as being owned by Joseph E. Hoopes. It was torn down in the mid-1960s when the property was sold to Smith Kline and French Laboratories for its animal health division. (East Goshen Township.)

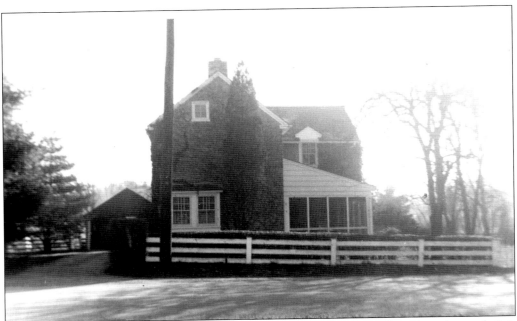

This house was originally located on Paoli Pike across from the East Goshen Township park. It is shown on the 1883 Breou Farm Atlas and was torn down sometime after 1964 when Smith Kline and French Laboratories purchased the surrounding property. It was the residence of James and Edna Bond from 1931 to 1951. (Edward Bond.)

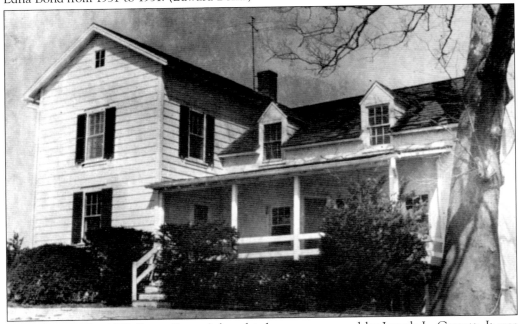

According to the 1883 Breou Farm Atlas, this house was owned by Joseph L. Garrett. It was torn down in the mid-1960s when the property was purchased by Smith Kline and French Laboratories for its animal health division. The original early Colonial portion of the house is located on the right in this photograph. (East Goshen Township.)

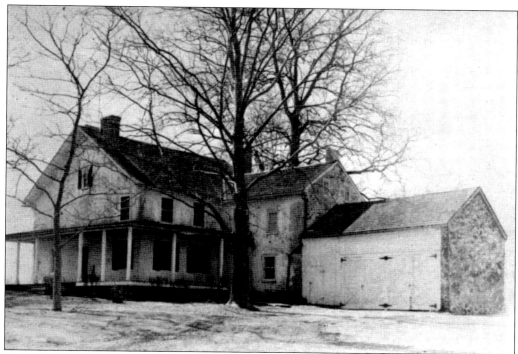

The original portion of this house, built around 1790, is the small stone portion between the larger portion, added around 1815, on the left of the photograph and the garage on the right of the photograph. Originally located on Line Road between Paoli Pike and East Boot Road, it was torn down in the mid-1960s when the land was purchased by Smith Kline and French Laboratories for its animal health division. (East Goshen Township.)

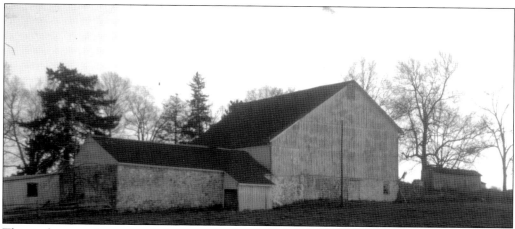

This is the stone barn that belongs to the farmhouse in the above photograph. The house and barn appear in the 1883 Breou Farm Atlas on the property of Chackley Singles. They were torn down in the late 1960s when the property was purchased by Smith Kline and French Laboratories for its animal health division. (Saunders Dixon.)

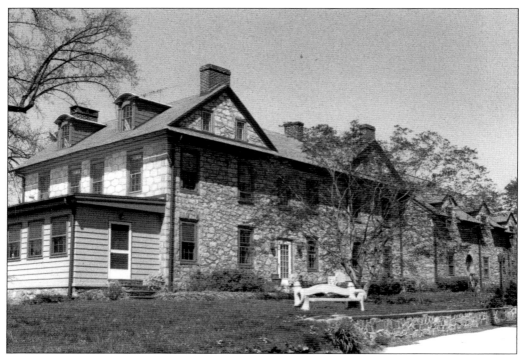

The Garrett/Hoopes house was built around 1790 and is located on Paoli Pike in the Goshenville Historic District. The house is of Georgian style with serpentine walls and has had three additions. It was purchased in 1956 by the St. Columban's Foreign Mission Society for priests on leave from foreign missions. The property was sold in 1979 and is now a private residence. (East Goshen Township.)

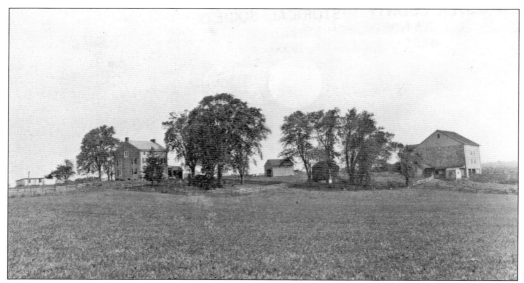

Shown here is the Phineas Pratt farm on property that was owned by John J. Sullivan when this photograph was taken in August 1929. The farm became part of the Hershey's Mill Village Adult Community. All the buildings were demolished in the 1970s. (CCHS.)

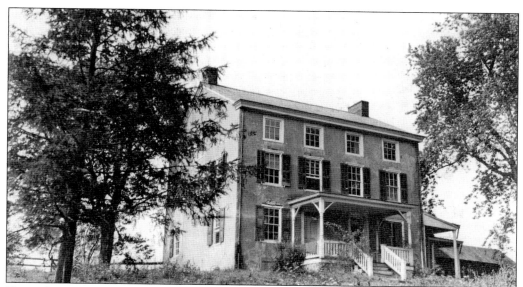

Shown here in August 1929 on the Sullivan farm is the Phineas Pratt house, which was originally located on Boot Road and built around 1859. The house was demolished in the 1970s when Hershey's Mill Village Adult Community was developed. (CCHS.)

This photograph from the late 1800s is of William T. Sharpless. According to his obituary, he was born in 1827, died on January 20, 1913, and was "one of the best known and oldest residents of Goshenville." He was a farmer and spent nearly his entire life in Goshenville. (East Goshen Township.)

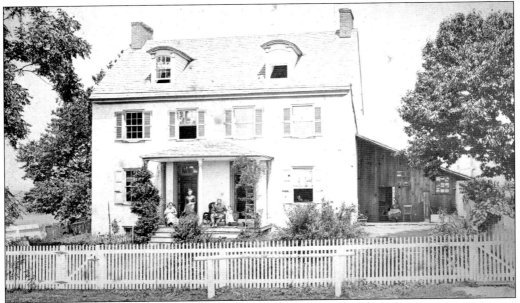

The Reese Meredith house, built around 1778, is shown in this photograph taken around 1880. In the photograph are William T. Sharpless, his wife Emma, and daughters Alice and Sara J. Hannah Redman is on the chair by the back shed. The house is located on Beaumont Circle in the development of Bow Tree. Sometime in the 1920s, the house was expanded with additions on either side of the original portion. (East Goshen Township.)

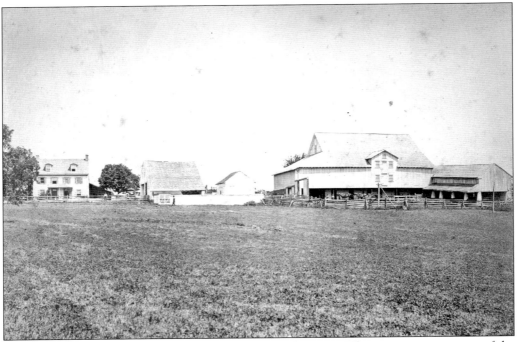

The Sharpless farm is shown here is as it appeared in the 1880s. The property is now part of the Bow Tree development on Route 352. (East Goshen Township.)

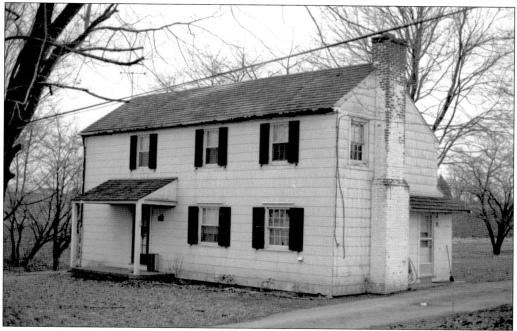

This tenant house appears on the 1883 Breou Farm Atlas on the Sharpless property. The exact date of construction is unknown. It was torn down in the mid-1980s when the Bow Tree development was built. (CCHS.)

This photograph, taken in 1900, shows Route 352 looking south from Paoli Pike. On the right is the Goshenville General Store/Goshenville Post Office, and on the left is the Goshenville Wheelwright and Blacksmith Shop. (CCHS.)

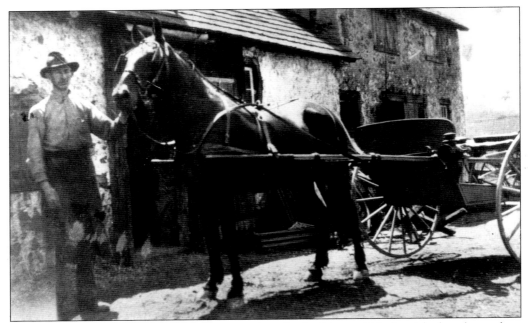

Wiebe Velde was the last blacksmith to use the wheelwright and blacksmith shop located on the southeast corner of East Boot Road and Route 352. He operated out of the building from 1915 until 1939, at which time he built his own shop across the street behind the house that he purchased some years before. (East Goshen Township.)

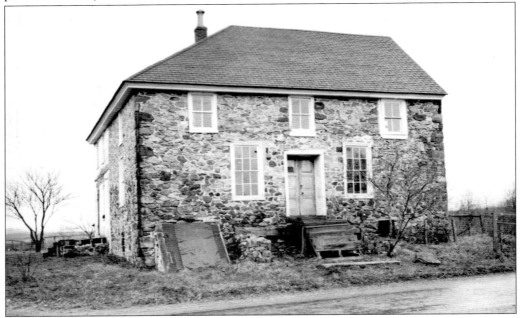

The Jesse Reese house was built in 1800 and is located in the Goshenville Historic District on Route 352. It is shown here in 1935. It served as the Goshenville General Store from 1806 to 1923 and as the Goshenville Post Office from 1828 to 1904. It was restored in 2003, and a large addition was added to the back of the building. It is now a bed-and-breakfast. (CCHS.)

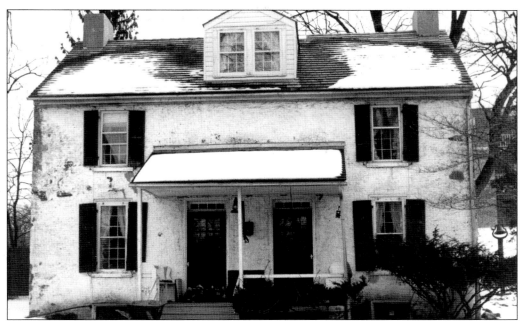

This house, located on Route 352 in the Goshenville Historic District, was originally constructed as a double house around 1800. It was converted into a single house in the early to mid-1800s. The house now sits nearly perpendicular to Route 352, but when it was built, Boot Road ran in front of the house. That section of the road has long since been abandoned. (CCHS.)

This is a photograph of the house on the White Chimneys farm that was built around 1829 and located on Route 352 north of Manley Road. It was torn down when the TreeTop Apartments were built in 1987. (Ruth Ann Harrison Weeks.)

This illustration from the 1881 *History of Chester County* by J. Smith Futhey and Gilbert Cope shows the Pratt Roberts house that was built in 1768 and located on East Boot Road. Roberts and his wife Ann enlarged the house several times over the 52 years they lived here. It is known today as the Clock Tower House because of the large clock tower built on the property. (CCHS.)

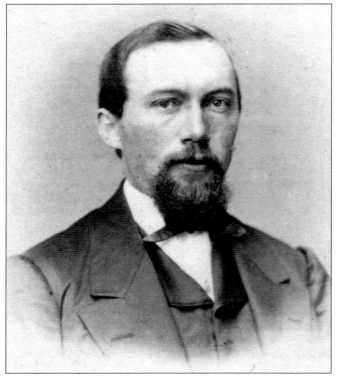

Col. George W. Roberts was born on October 2, 1833. He was the eldest son of Pratt Roberts and his wife Ann (Wilson) who owned Bellevue Farm on East Boot Road. He was admitted to the bar in 1858 and practiced in West Chester until 1859 when he moved to Chicago. He joined the Union army in July 1861 and was killed on December 31, 1862, at Stone River (near Murfreesboro). (CCHS.)

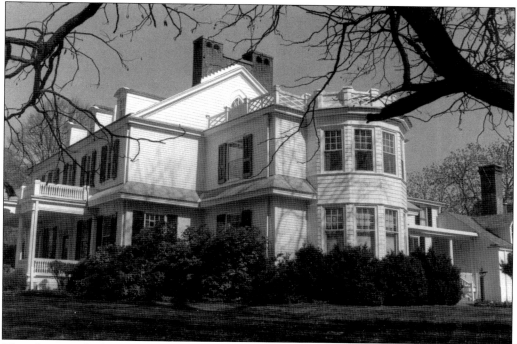

This photograph shows the 1890s dining room and master bedroom suite addition to the Pratt Roberts house on East Boot Road. (East Goshen Township.)

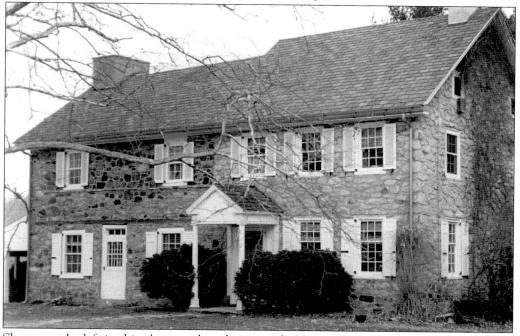

Shown on the left in this photograph is the original 1750–1770 fieldstone house that is located on Paoli Pike. The green serpentine stone Georgian section, on the right, is believed to have been built by Joseph Eldridge in the early 1800s. (CCHS.)

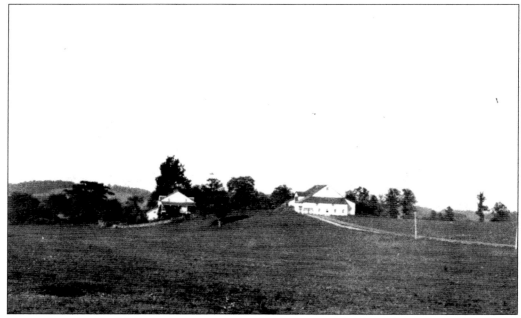

Shown here in the 1920s is the property locally known as the Jesse Priest farm. The house remains on what is now Williams Way, but the barn was torn down in 1962 when the property was subdivided into lots for the housing development known as Ashbridge. (Frank and Cathy Hoffmann.)

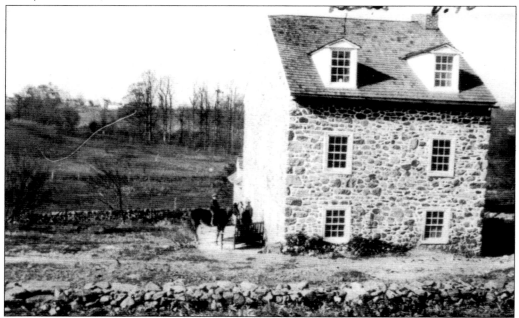

This house was built in 1829 by stone mason Jesse Priest, who lived here for 50 years. This photograph was taken in 1934 and shows the front of the house, with Isaac Tripp at the age of eight on the horse. His parents are standing next to him. The house still stands on Williams Way in the development of Ashbridge. (Frank and Cathy Hoffmann.)

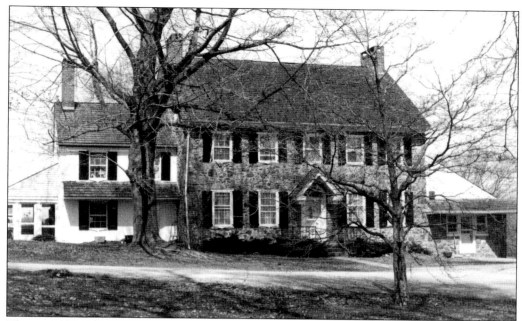

This is a 1981 photograph of Meadowview Farm, which is located on Ellis Lane. The portion of the house located behind the tree on the left was built by Robert Roberts around 1800. The main part of the house was built in 1812 by John Marshall. The house has remained in the same family since 1872. (CCSH.)

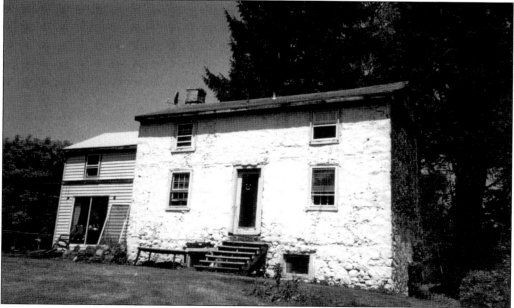

This small tenant house was originally built around 1800 and located on the Meadowview Farm. It was torn down in 2003 when the property was sold to the West Chester Area School District for ball fields for East High School. (East Goshen Township.)

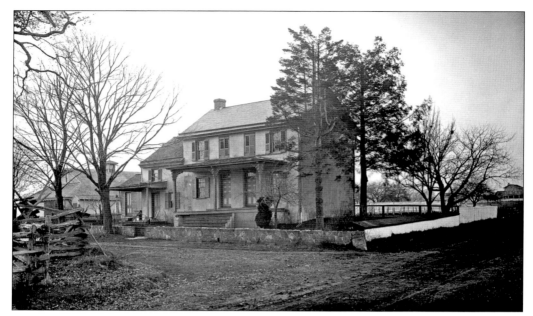

This 1899 photograph is of a tenant house, which was built around 1770 and located on the northwest corner of Manley Road and Route 352. In 2007, when apartment buildings were built on the site, the house was moved to the west end of the property and converted into two units. (CCHS.)

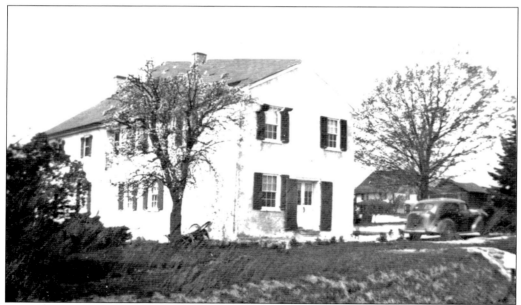

Shown here in 1946 and located on East Strasburg Road in Rocky Hill is a 1759–1795 Federal-style residence. A stone addition on the east side (shown in this photograph) originally contained a store on the first floor. In 1885, Capt. Charles W. Roberts added the second floor to be used as a community hall. The Cloud Post Office was established here on January 20, 1881, and operated into the early 20th century. The building is now a private residence. (CCHS.)

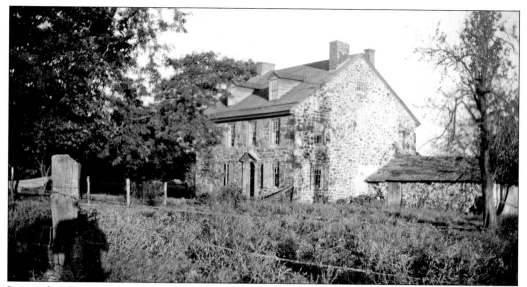

Located on East Strasburg Road in Rocky Hill, this 1725–1740 fieldstone farmhouse has expansive wide gables, a box cornice, paneled shutters, gabled dormers, and a formal main entrance design with an elliptical fanlight and pilasters. This photograph was taken in 1938. The house looks much the same today as it did in this photograph. While no longer a working farm, the property still contains the original fieldstone barn and carriage house. (CCHS.)

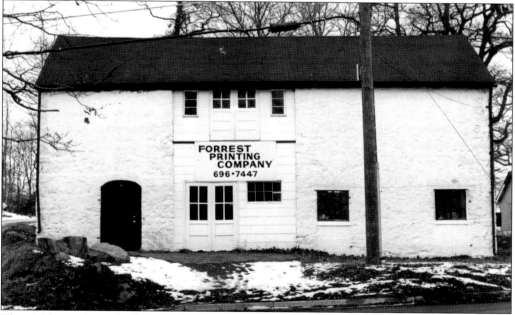

This fieldstone barn, built around 1800, is shown here in 1981 and is located on the corner of East Strasburg Road and Route 352. In 1850, it was known as Jonathan Cope's stable. The white paint was removed, and the barn door was replaced with glass divided into 11 sections in the mid-1980s. This barn has retained its architectural integrity through adaptive reuse as an office building. (CCHS.)

This English Colonial was originally built around 1874 as a tenant house for the farmhouse on the southwest corner of East Strasburg Road and North Chester Road in the area known as Rocky Hill. (CCHS.)

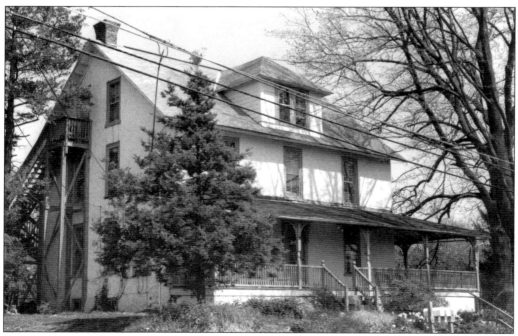

This Italianate-style house, located on East Strasburg Road in Rocky Hill, is stucco over frame and was constructed in 1886 by Phineas Pratt. (East Goshen Township.)

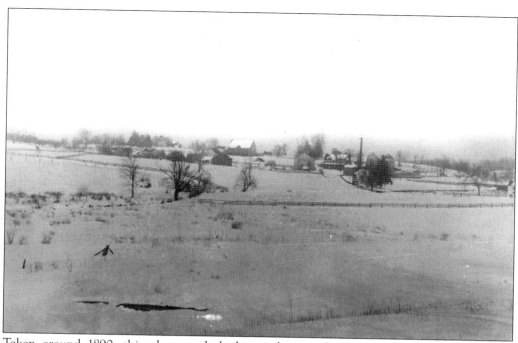

Taken around 1890, this photograph looks north toward Milltown (buildings in the left background) from the area now known as Goshen Heights. The Hoopes farm is the large barn in the center, and the Sheaf of Wheat Inn is the building just to the left of the smokestack. The tall smokestack belongs to West Chester Pumping Station. (Louis F. Smith.)

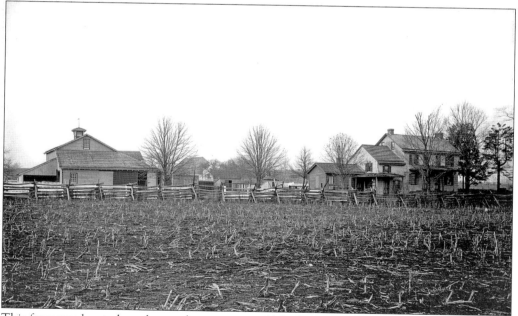

This farm was located on the northwest corner of Manley Road and Route 352. Shown here in December 1899, it was then owned by Albert Enkrekin. The home was originally built around 1770 as a tenant house on property owned by George Ashbridge III. (CCHS.)

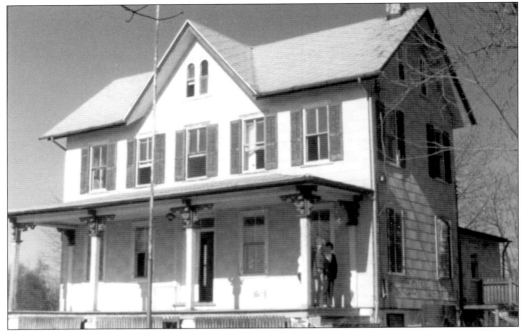

This Victorian was originally built around 1880 and located on what is today called Hilloch Lane. Located on the property of William Burns, who was a master carpenter and known for doing high-quality work, it was abandoned, and the Goshen Fire Company was given permission to burn it down as a training drill in 1988. (Diane Degnan.)

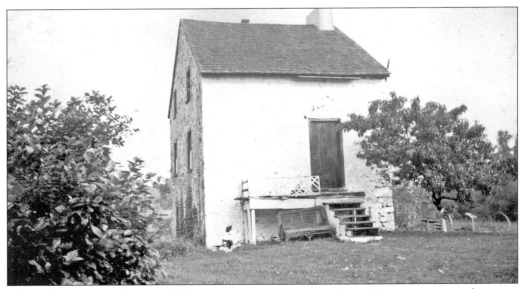

The building shown here in 1938 is a mystery, as its exact date of construction and use are unknown. It was originally located on Manley Road on what is now Hilloch Lane. While it appears to be a house, it had no windows in the front or rear and the door was exceptionally large. There was also a door on the lower level and fireplaces on both the lower level and first floor. It was demolished in 1988. (CCHS.)

Located on West Chester Pike between Ellis Lane and Reservoir Road, this house is an excellent early example of the Second Empire style. It was built in 1872 by William and Hannah Hoopes. Much of the original interior features of the house remain. William Hoopes was well known and operated a dairy farm. His farm was better known for its unusual crop—asparagus. His asparagus was greatly valued and sold in Philadelphia. (Louis F. Smith.)

This large stone barn, built around 1870, was on the William Hoopes farm located on the north side of West Chester Pike west of Reservoir Road. The barn fell into disrepair and was torn down in 1986. (Louis F. Smith.)

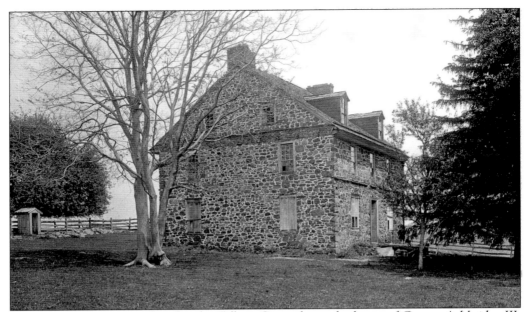

This May 1899 photograph, taken by Gilbert Cope, shows the home of George Ashbridge III, built around 1760. The house is located on West Chester Pike near Reservoir Road and is currently used as an office building. Ashbridge operated a gristmill on the south side of West Chester Pike at the site of the old West Chester Pumping Station. (CCHS.)

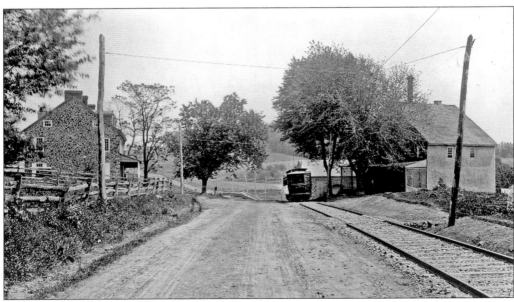

Trolley service from Sixty-third Street in Philadelphia that ran along West Chester Pike to West Chester began in 1899 and continued until 1954. This photograph from 1899 was taken looking east along West Chester Pike by the Sheaf of Wheat Inn (left). (CCHS.)

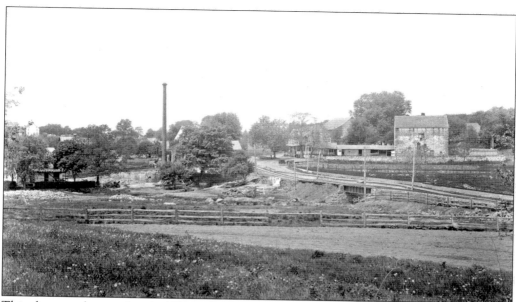

This photograph was taken in 1899 and is a view from Westtown Way (foreground) looking west along West Chester Pike. The tall smokestack on the left is the West Chester Pumping Station, and the building on the right is a stone barn, which was connected to the Sheaf of Wheat Inn. (CCHS.)

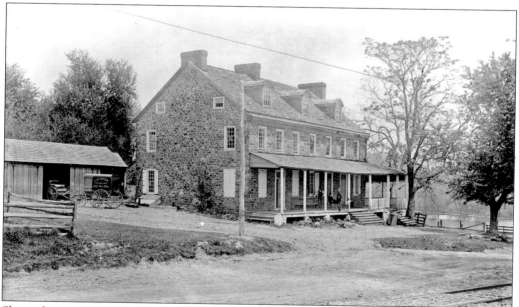

Shown here in 1899, the Sheaf of Wheat Inn, built around 1720 at the corner of Reservoir Road and West Chester Pike, served not only people on their way to and from Philadelphia but was also a gathering place for locals. The building still stands today and has been converted into offices. (CCHS.)

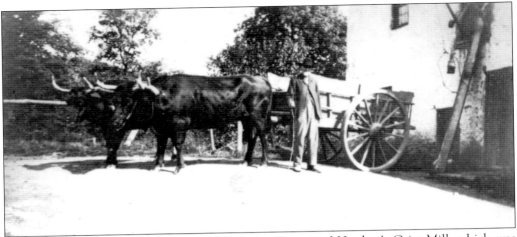

This 1890s photograph shows Enoch P. Hershey, owner of Hershey's Grist Mill, which was located at the corner of Greenhill Road and Hershey's Mill Road. The first record of a mill on the property appears in 1806 when Thomas Rees willed it to his son Benjamin. In 1878, Rachel Hershey inherited the land from her father. The building is currently a private residence. (East Goshen Township.)

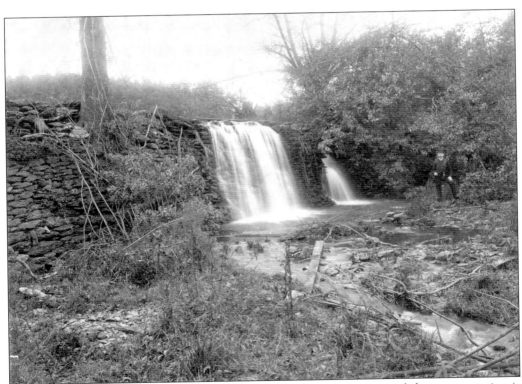

Shown here in 1890 is the Hershey's Mill Dam. The date of the original dam construction is not known; however, the dam was rebuilt in 1904 according a newspaper clipping at the Chester County Historical Society, which said that "the breast of the dam has been completed after a vacation of several months." (CCHS.)

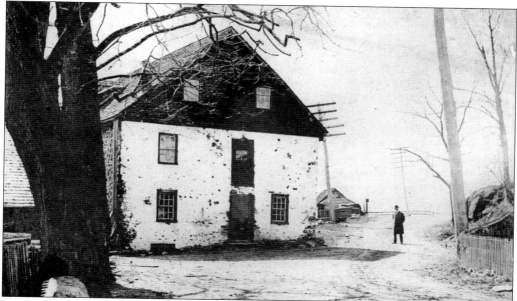

This 1898 photograph is of the 1813–1838 Dutton's Mill, which was originally located on the southeast corner of East Strasburg Road and Dutton Mill Road and operated as a gristmill and a sawmill. In the mid-1890s, Henry H. Dutton installed presses to make cider. In 1899, he advertised, "I am prepared to make cider at 1 1/2 cents per gallon on short notice. Guarantee four gallons to the bushel out of ripe apples." The building was demolished in the early 1900s. (CCHS.)

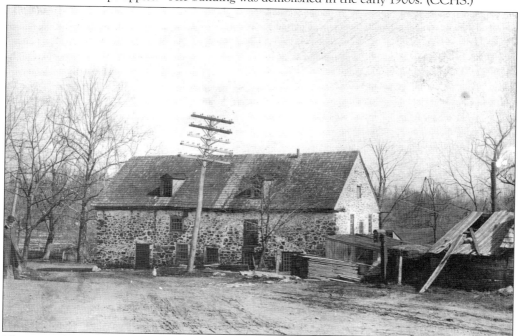

This is a side view of Dutton's Mill as it appeared in 1898. It sat along Dutton Mill Road, which was then known as Township Line Road. The mill was located just west of Dutton Mill Road and north of the Ridley Creek. (CCHS.)

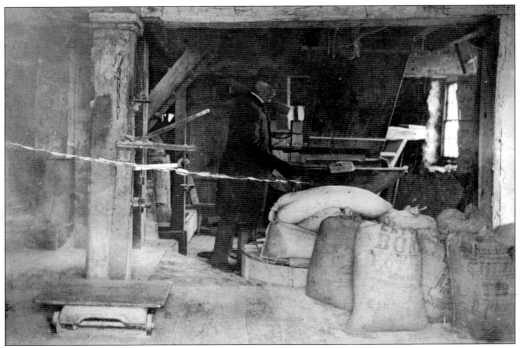

This 1898 photograph shows Henry H. Dutton and the inside of his mill located on East Strasburg Road and Dutton Mill Road. The sacks may contain apples for his cider press. (CCHS.)

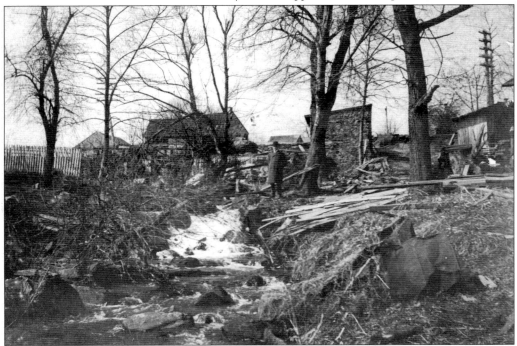

This photograph from 1898 is of the Ridley Creek, which ran behind Dutton's Mill on East Strasburg Road. The man in the photograph is probably Dutton, owner of the mill. (CCHS.)

Christian G. Dutt was the owner of Dutt's Mill from 1865 until his death in 1899. The mill was located on Westtown Way. The mill was originally built in 1790 as a cotton mill and was converted into a woolen mill by Dutt. The mill was named the Milltown Woolen Mills in 1912 and continued to be operated by the Dutt family until 1920 when it was sold to James T. Byrne of Philadelphia. He operated the mill for a short time but ceased operations, and the property was sold under sheriff sale. (CCHS.)

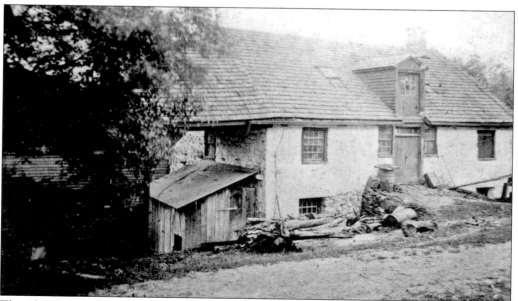

This photograph shows Dutt's Mill in the late 1800s when it was a woolen mill. (CCHS.)

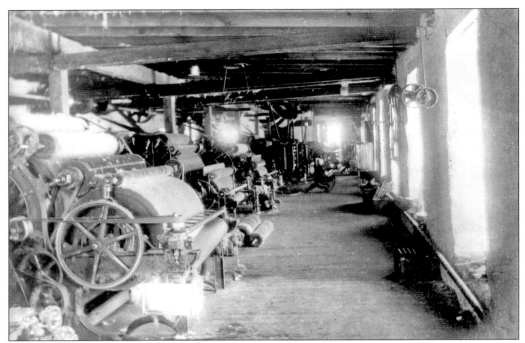

Seen in the late 1800s is the card room at Dutt's Mill where the wool was prepared for spinning into yarn. (CCHS.)

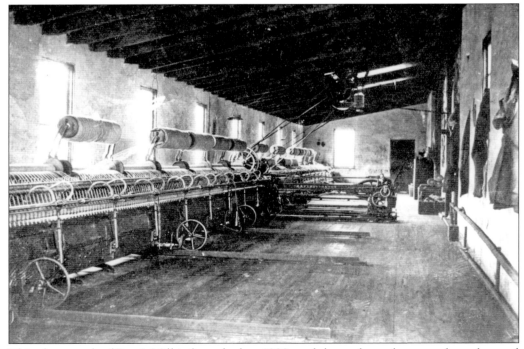

This photograph of Dutt's Mill is from the late 1800s and shows the mule room where the wool was spun into yarn. (CCHS.)

Two

SCHOOLS, CHURCHES, AND GOSHEN FIRE COMPANY AND FAIR

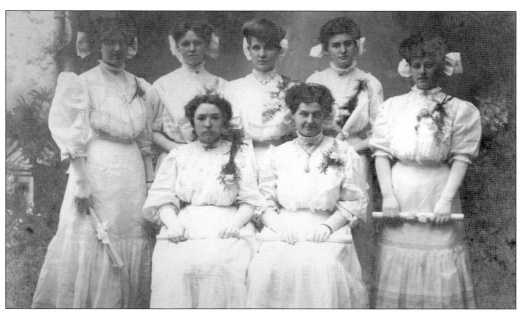

This photograph shows young women from the graduating class of 1907 from the East Goshen High School, which was located on the second floor of the Goshenville School from 1894 until 1913. The names of the young women are (in alphabetical order) Mary Boyd, Anna Cloud, Bertha Hartshorne, Anna Hicks, Eva Mosteller, Lena Powell, and Mary Taylor. Anna Hicks is in the front row on the right. (Ira Hicks family.)

Pictured here is the Goshen Heights School, which was built in 1916 and located on School Lane south of West Chester Pike in the Goshen Heights neighborhood. The building was torn down in 1980. (CCHS.)

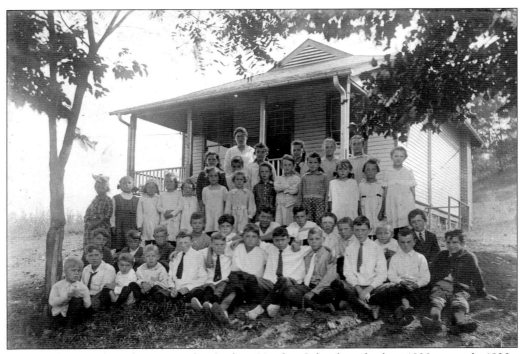

Here students and teacher are at the Goshen Heights School in the late 1920s or early 1930s. (John and Marty Windle.)

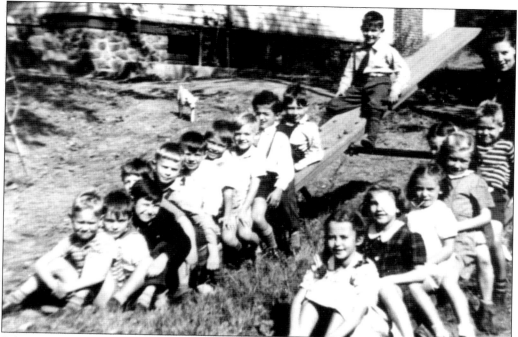

Schoolchildren at the Goshen Heights School are on the seesaws in this 1941 photograph. (John and Marty Windle.)

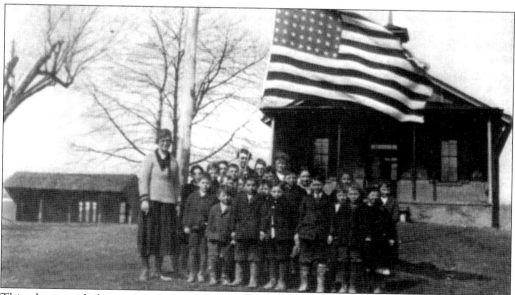

This photograph from 1923 shows the Maple Grove School, built around 1884 and located on Greenhill Road. The teacher in the photograph is Bertha Hicks. In 1931, the school was closed and the children transferred to other schools in the township. In 1938, the school district sold the building, and it has been a private residence ever since. From 1948 until 1974, it was the home of Dorothy Henderson Pinch, the sister of Marjorie Henderson Buell, who was the author of the Little Lulu cartoon character. (Mary Ann Minnis.)

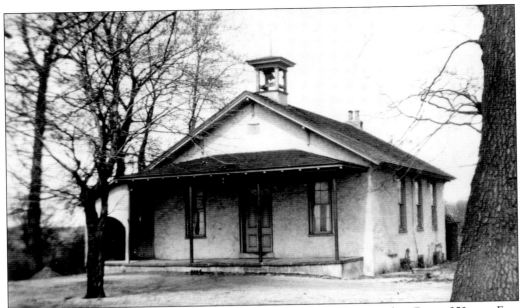

Shown here in 1949, the Rocky Hill School was built in 1879 and located on Route 352 near East Strasburg Road. It was constructed to replace the 1853 school, which had developed a crack that could not be checked. In 1955, a new East Goshen Elementary School was constructed, and the Rocky Hill School was sold. It was converted into a residence by the new owner, who still owns it. The old school bell, dated 1879, still resides in its original location on the roof. (CCHS.)

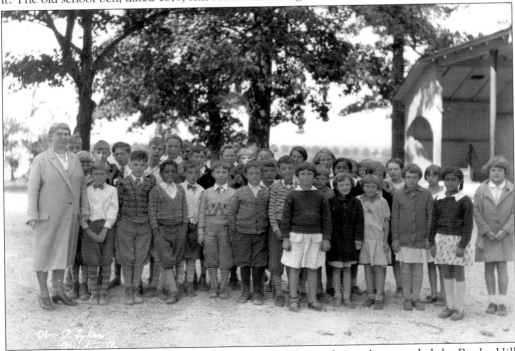

Shown here in 1928 are teacher S. Agnes Taylor and the students who attended the Rocky Hill School. (Louis F. Smith.)

The Goshenville School was built in 1873. From 1894 until 1913, the second floor of the school served as the East Goshen High School. In 1913, the high school was closed and the students were sent to the West Chester High School. The Goshenville School served the elementary students until 1955 when it was sold. Located at Paoli Pike and Route 352, it is currently the East Goshen Bible Church. (Louise and George Velde Jr.)

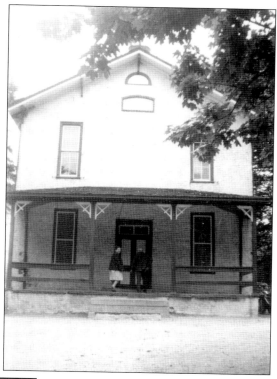

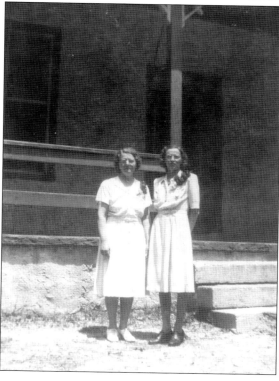

Seen in this 1945 photograph are principal Margaret Davis, left, and teacher Margaret Miller at the Goshenville School located on Route 352. (Phyllis Marron.)

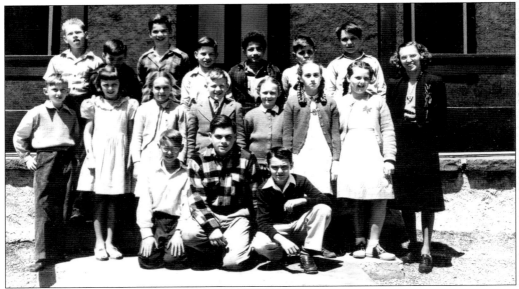

The 1947 fifth- and sixth-grade classes of the Goshenville School on Route 352 are shown here. From left to right are (first row) Wayne Grunwell, John Gustason, and unidentified; (second row) Clark Dilworth, unidentified, Joan Grunwell, Stephen Plummer, Bernice Hoopes, Blanche Craig, Marjorie Parry, and teacher Margaret Miller; (third row) Ralph Green, David Bond, Peter Staudenmaier, unidentified, Francis Barbarti, Raymond Rennard, and Richard Smith. (Louise Velde.)

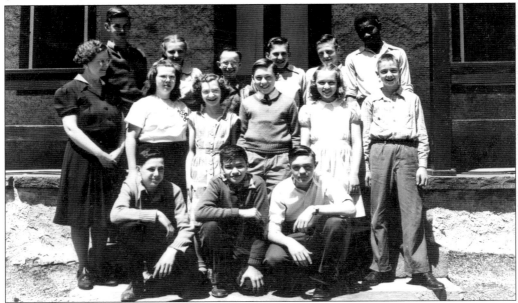

The 1947 seventh- and eighth-grade students at the Goshenville School on Route 352 are shown here. From left to right are (first row) Billy Johnston, Carl Stuart, and Gerald Hess; (second row) teacher Margaret Davis, Jean Brooks, Louise Parry, Richard Reynolds, Milly Stafford, and Billy Grunwell; (third row) Bobby Stafford, Mary Clay, David Roe, Louis Thomas, Edward Hartshone, and Richard Lewis. (Louise Velde.)

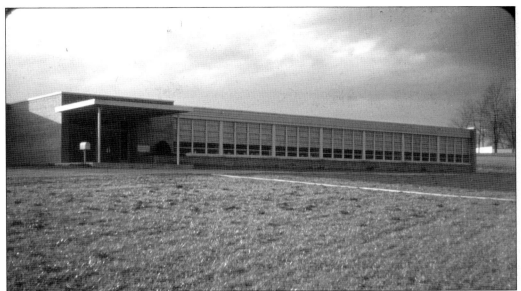

This photograph from 1957 shows the East Goshen Elementary School, which was built in 1955 on Route 352 south of Paoli Pike. It replaced the Goshenville School, the Rocky Hill School, and the Goshen Heights School. The school has been expanded several times over the years and now has over 500 students in kindergarten through the fifth grade. (Stephen Plummer.)

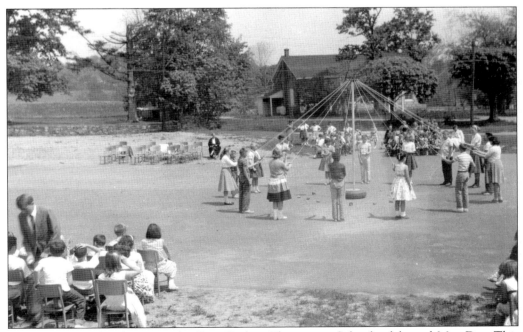

In the 1950s and early 1960s, the East Goshen Elementary School celebrated May Day. This photograph is from 1958 and shows the students preparing for the maypole dance. Across the street is the Goshen Grange. (Ira Hicks family.)

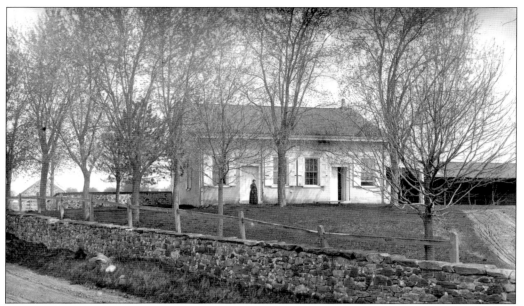

This photograph, taken in 1899, is of the Goshen Friends Meeting House in Goshenville at Route 352 and Paoli Pike. This building was constructed in 1836 (left side of building) and enlarged in 1855 (right side of building). The first meetinghouse was a log building constructed in 1709 just north of this building. In 1736, it was torn down, and a stone building was constructed in its place. It was demolished in 1964. (CCHS.)

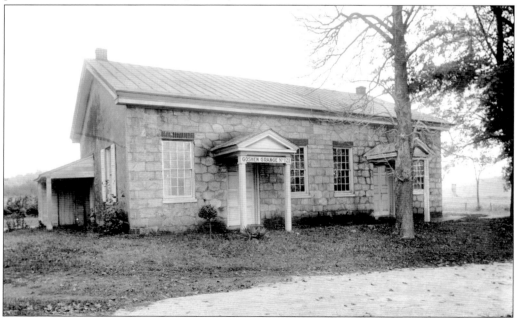

This building is located on Route 352 and was built in 1849 when the Goshen Friends split into two groups: the Hicksite and the Orthodox. It was occupied by the Orthodox Friends until 1891. In 1920, it was sold to Goshen Grange No. 121, which owned it until 1990 when the Friends repurchased the building for the Friends Elementary School. (CCHS.)

The Goshenville Presbyterian Chapel was founded in 1878 and served the community until 1935. The chapel was a branch of the First Presbyterian Church of West Chester. The building was sold in 1943 and later demolished. It was originally located on the west side of Route 352 on the Ridley Creek. (Virginia Shainline.)

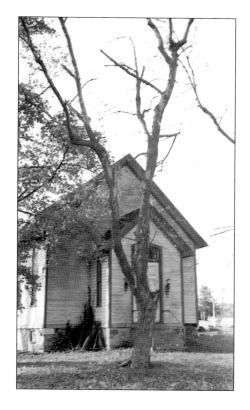

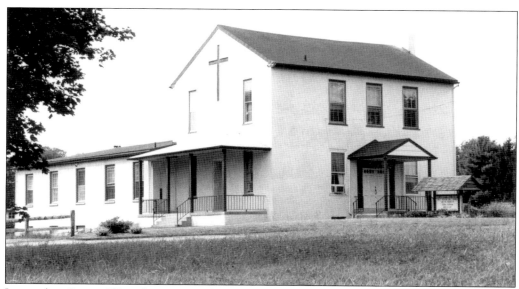

Located on Route 352 and constructed as the Goshenville School, the building was sold by the West Chester School District in 1955 and became the Church of Goshenville. The name was changed to the East Goshen Bible Church in 1979. (East Goshen Township.)

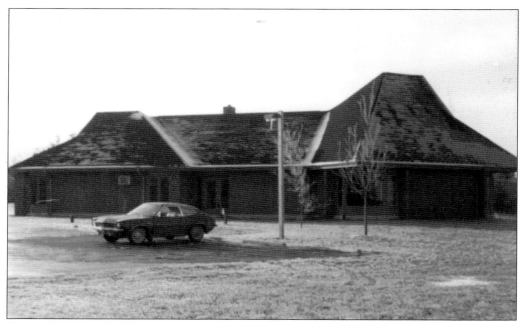

Shown here shortly after construction was completed, the United Church of Christ, located on Route 352 and Greenhill Road, was built in 1972. The first church service was celebrated on June 4, 1972. From 1968 until the church was built, the congregation met in the homes of parishioners and then at the SS. Peter and Paul Catholic Church on Boot Road. (Steven Yost.)

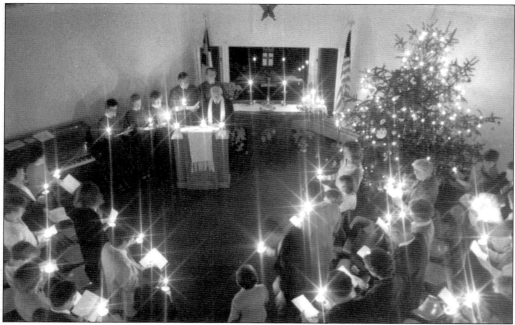

Shown here is the 1982 Christmas Eve service at the United Church of Christ located at Greenhill Road and Route 352. (Steven Yost.)

SS. Peter and Paul Catholic Church is located on Boot Road and is shown here in 1969 shortly after the building was constructed. The formal dedication by John Cardinal Krol took place on May 9, 1970. In 2001, the church built a new school for prekindergarten through eighth grade. (SS. Peter and Paul Catholic Church.)

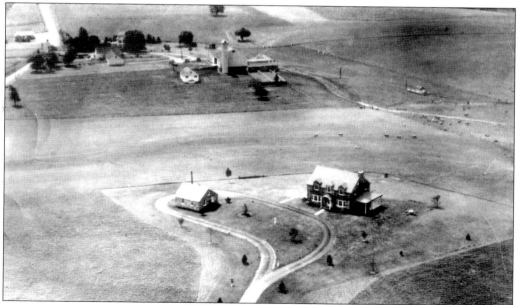

Shown here in 1941 is the farm of Gertrude Riley McDaniel in Westtown Township on West Chester Pike on which the SS. Simon and Jude Catholic Church was constructed in 1962. The house in the center of the photograph is now the church rectory. This photograph has been included because many East Goshen Township residents are members of this parish. (SS. Simon and Jude Catholic Church.)

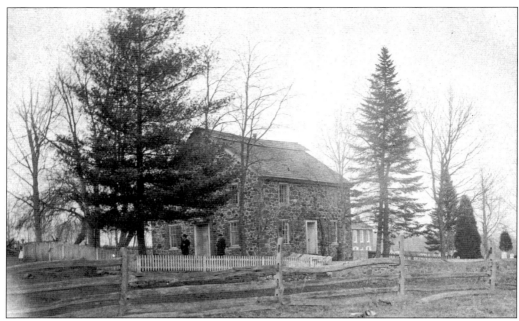

The Goshen Baptist Church was built in 1809 and located at the corner of East Strasburg Road and West Chester Pike in what is now West Goshen Township. In 1817, Goshen Township was split into East Goshen and West Goshen. The above photograph shows the original stone church sometime between 1850 and 1874. It was destroyed by fire in 1874. (Goshen Baptist Church.)

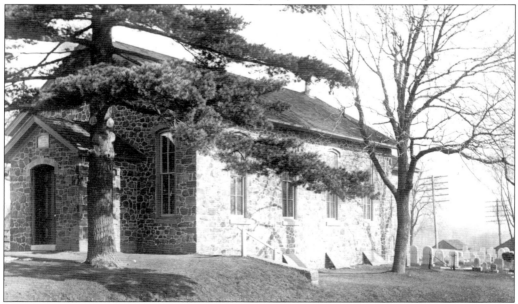

Shown here is the Goshen Baptist Church, which was built in 1874 to replace the one that burned down. The church remained at this location until 1970 when a new church was built in East Goshen Township on a six-acre site farther east of the original location. When the new church was built, all 172 graves were carefully disinterred and, together with their original gravestones, moved to the new site. (John Windle.)

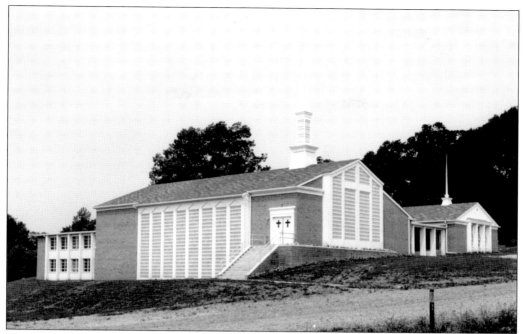

The Goshen Baptist Church moved from its original location at East Strasburg Road and West Chester Pike in West Goshen Township in 1970 to its present location on West Chester Pike and Waterview Road in East Goshen Township. This photograph shows the church shortly after construction was completed. (CCHS.)

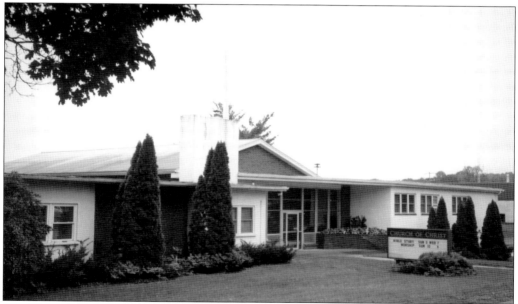

The Church of Christ located on Park Avenue was founded in 1941, and members worshipped in West Chester at several different locations until 1956 when the portion shown in the left of the photograph was built. In 1960, the center and right portions of the building were added. (East Goshen Township.)

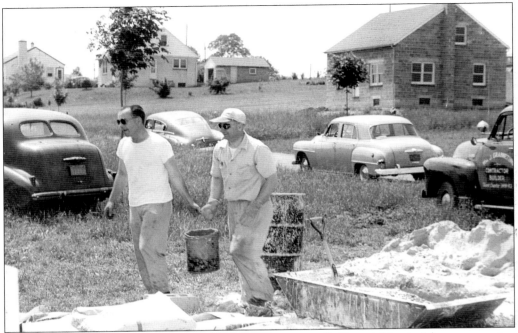

Pictured in this 1951 photograph are Robert Thompson (left) and Norris Johnson carrying cement to construct the new Goshen firehouse on Park Avenue. The houses in the background are on Park Avenue. (William Keslick.)

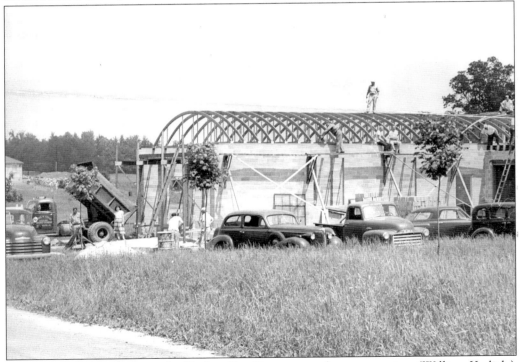

This 1951 photograph shows the Goshen Fire Company under construction. (William Keslick.)

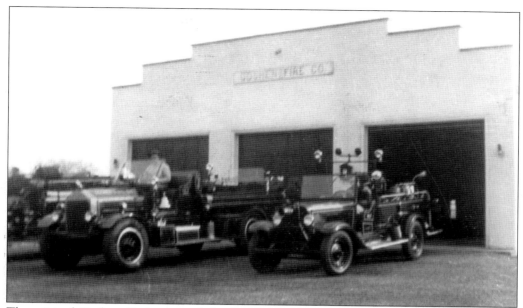

The original Goshen Firehouse and the first fire trucks are pictured in this 1953 photograph. The Goshen Fire Company was officially organized in 1950 by Guy Chillas, J. Fred LaChappelle, Herbert "Bud" Schmitt, Joseph Supplee, Tom Smith, and Herbert Stafford. In November 1950, Harry F. Taylor donated two acres of land along Park Avenue for the fire station, which was built in 1951. (Roy and Josie Herron and JoAnne Wright.)

This 1953 photograph is of the first fire truck purchased by the Goshen Fire Company. It was purchased from the Paoli Fire Company. At the wheel is Harold Price. (Roy and Josie Herron and JoAnne Wright.)

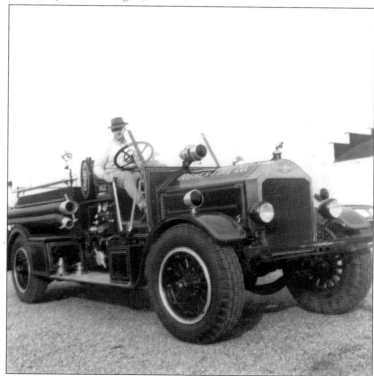

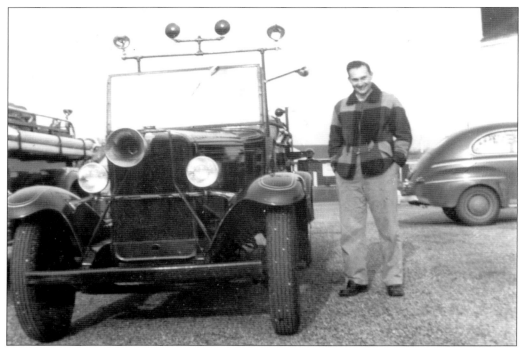

Shown here is Lew Metzgar in 1953 with one of the first three fire trucks owned by the Goshen Fire Company. (Roy and Josie Herron and JoAnne Wright.)

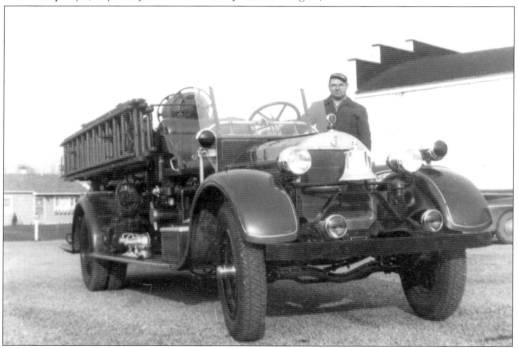

This photograph from 1953 shows Roy Herron with one of the first three fire trucks owned by the Goshen Fire Company. (Roy and Josie Herron and JoAnne Wright.)

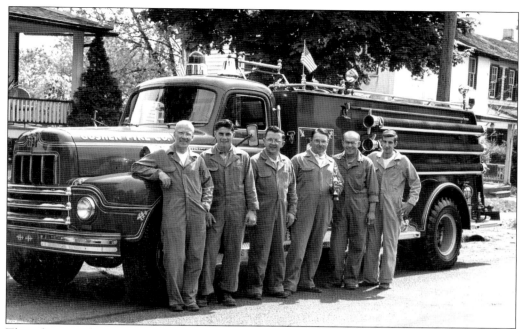

This photograph was taken on May 14, 1955, and shows the first "new" fire truck purchased by the Goshen Fire Company. It was built by Robert Wiggins Fuel Oil Truck Company. The volunteer firemen from left to right are Edward Gerrige, Jerry Thornton, Tom Supplee, Roy Herron, Robert Thompson, and Paul Hutchinson. (Roy and Josie Herron and JoAnne Wright.)

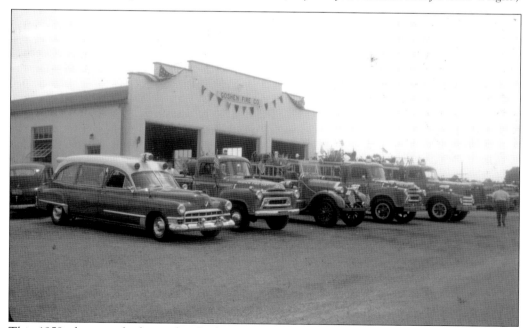

This 1959 photograph shows the Goshen Fire Company's new ambulance. The truck in the middle is the only one remaining of the original three purchased when the fire company first started in 1951. (Roy and Josie Herron.)

This 1972 photograph of the Goshen Fire Company shows the first expansion of the building in 1963. (CCHS.)

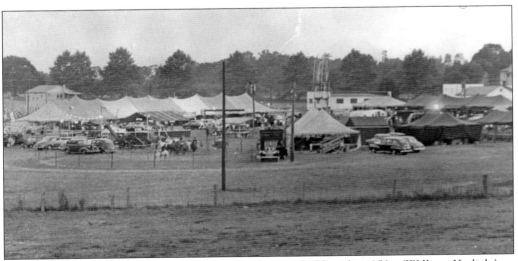

This is a photograph from one of the first Goshen Fairs held in the 1950s. (William Keslick.)

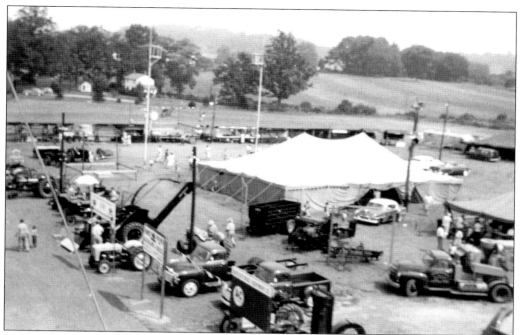

In 1952, East Goshen Township was still largely a farming community, and the Goshen Fair gave local farmers an opportunity to view the latest equipment and vehicles. (Ira Hicks family.)

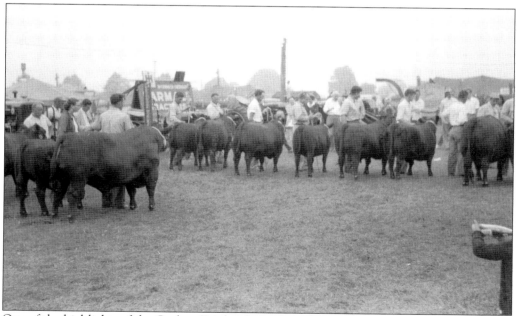

One of the highlights of the Goshen Fair has been the judging of livestock. Shown here in 1952 are Black Angus cattle being judged. (Ira Hicks family.)

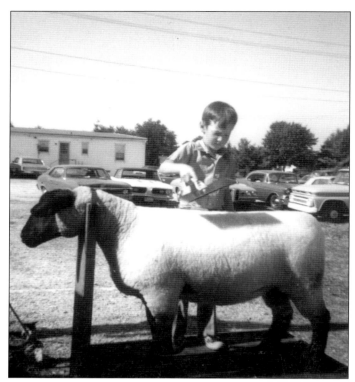

This photograph from the early 1960s shows a young boy grooming his sheep in preparation for the livestock judging at the Goshen Fair. (William Keslick.)

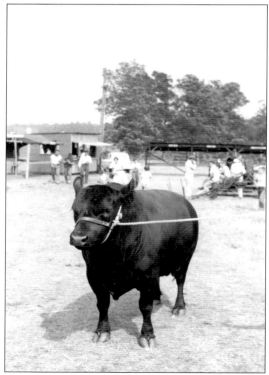

One of the prized Black Angus cattle that were shown at the Goshen Fair is pictured here in 1952. (Ira Hicks family.)

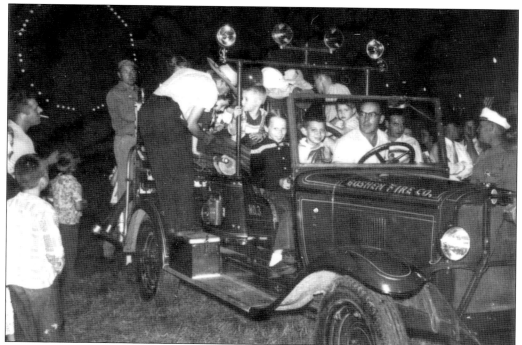

Shown here in 1952 are children getting ready for a ride in an old fire truck at the Goshen Fair. The driver of the truck is Robert Thompson, and standing on the back is Roy Herron. (Sarah Credeur.)

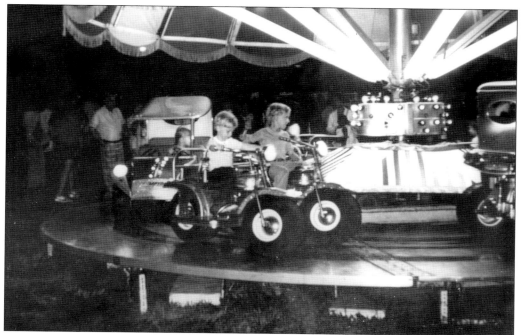

This photograph shows children enjoying a ride at the Goshen Fair in the 1970s. (William Keslick.)

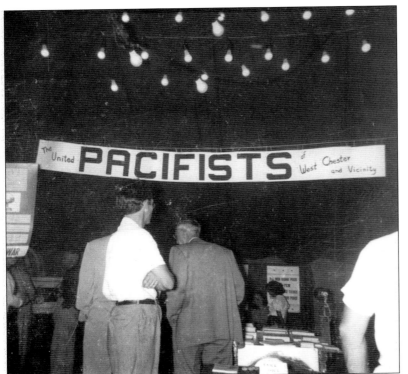

The Goshen Fair offers the opportunity for many different organizations to display their services and products. This photograph, which was taken at the 1952 fair, shows the booth of the United Pacifists of West Chester and Vicinity. (Saunders Dixon.)

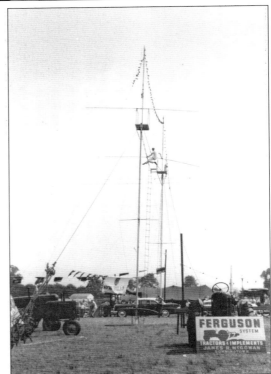

Shown here in 1959 is the tightrope walker at the Goshen Fair. (Ira Hicks family.)

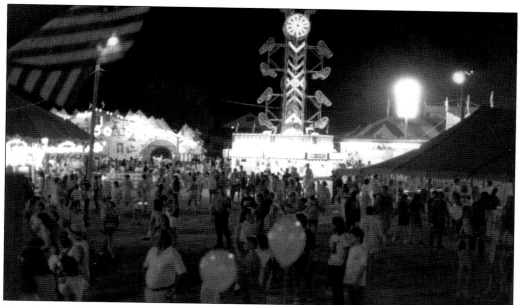

The Goshen Fair has been an institution since its first appearance in 1949. While the area has gone from farms to suburbia, the Goshen Fair retains many of its original attractions. The rides have become bigger, but the atmosphere of an old-time country fair still abounds, with livestock to be judged, bakery goods to be tasted, games of chance to be played, and many exhibits from local businesses to be seen. (Margie Ferguson.)

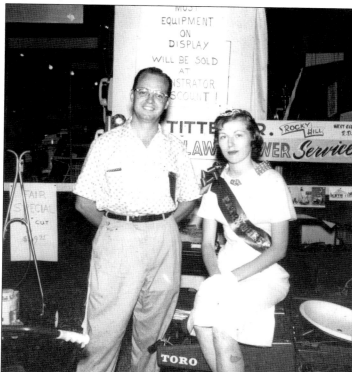

Shown here is the 1960 Goshen Fair queen, Stella Parry, with William Titter of Titter's Lawn Mower Service, which was located on East Strasburg Road east of Route 352. (Sarah Credeur.)

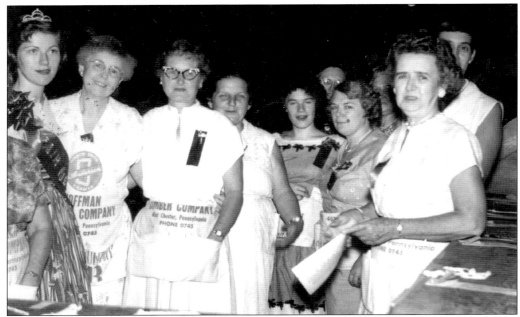

The Goshen Fire Company Ladies Auxiliary performed many duties at the Goshen Fair. Shown selling raffle tickets in 1960 from left to right are fair queen Stella Parry, unidentified, Dot Hull Engsfeldt, Edith Parry, unidentified, unidentified, Helen Bates, and Dot Stafford. (Stephen Plummer.)

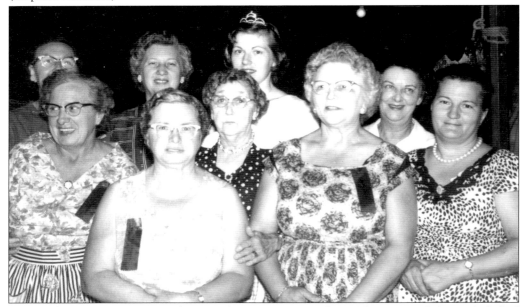

The Goshen Fire Company Ladies Auxiliary was organized in 1951. It started the craft, baked goods, attic, and flower booths at the fair as a way to help the firemen raise money for equipment. Shown here in 1960 from left to right are (first row) unidentified and Edith Seeds; (second row) unidentified, Edith Darlington, and Thelma Little; (third row) unidentified, unidentified, Stella Parry, and Marie Leach. (Sarah Credeur.)

Three

THE RURAL YEARS

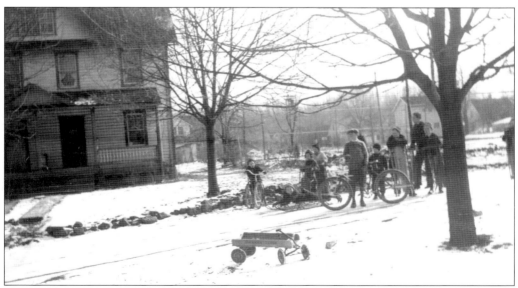

This photograph was taken on Locust Street in Goshen Heights sometime in the early 1930s. (Louis F. Smith.)

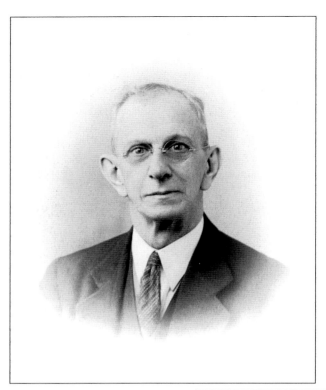

Known as "Squire Taylor," Harry F. Taylor moved to East Goshen Township in 1899 and resided there until his death in 1960 at the age of 85. He developed Goshen Heights and Milltown Manor. He was active in many community organizations, served as the justice of the peace for East Goshen Township for over 48 years, and was township supervisor from 1907 until 1922. He donated the land on which the Goshen Fire Company was built. (CCHS.)

This is a plan for the first residential subdivision in the township. Taylor subdivided his property in 1910 and called it Goshen Heights. While there were other neighborhoods in the township, including Rocky Hill, Goshenville and Milltown, Goshen Heights was the first planned subdivision. (Louis F. Smith.)

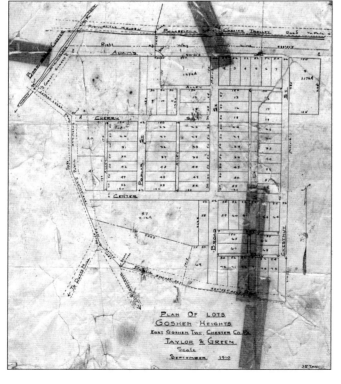

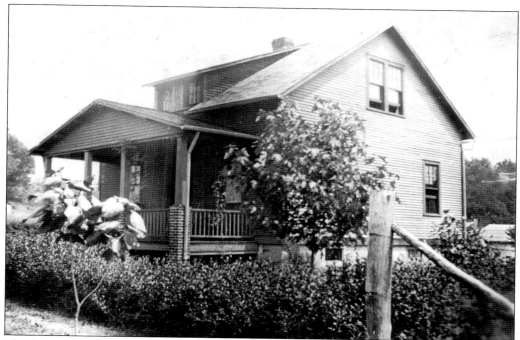

This Sears Roebuck and Company house was built in 1909 on Center Street in Goshen Heights by George and Mary Baldwin. The house cost $495 and was shipped in by train. (Anna Baldwin.)

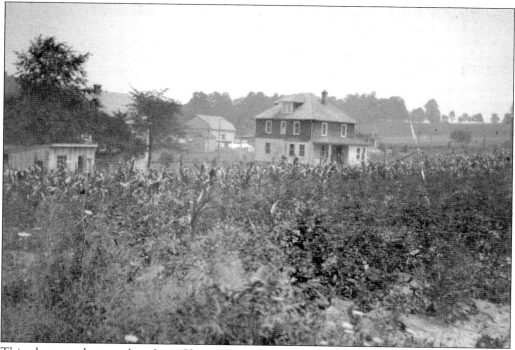

This photograph was taken from Cherry Street in Goshen Heights looking north toward West Chester Pike. It was taken sometime in the 1920s. (JoAnne Wright.)

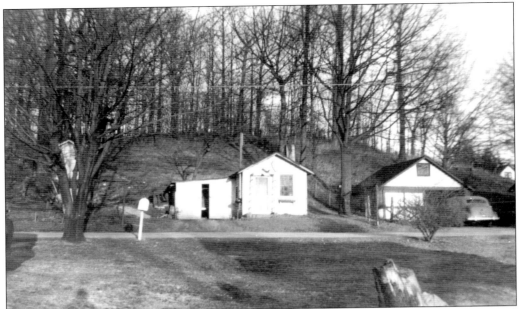

The small house in the center of this 1940s photograph was the home of George Thompson and was located on School Lane in Goshen Heights. The first Goshen Fire Company ambulance was stored in the garage (on the right in the photograph) until the fire company building was constructed. (Stephen Plummer.)

This 1920s house was built on Center Street in Goshen Heights by Frank C. Hartshorne. (Stephen Plummer.)

This is a 1951 advertisement for homes on Park Avenue. (CCHS.)

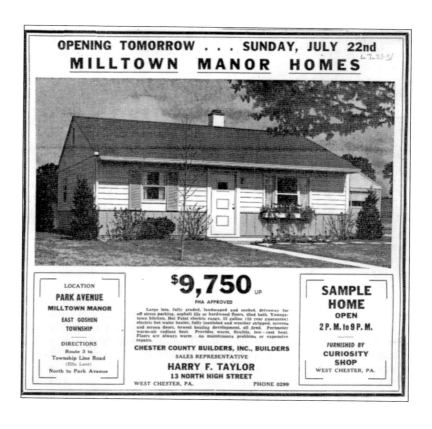

OPENING TOMORROW . . . SUNDAY, JULY 22nd
MILLTOWN MANOR HOMES

$9,750 UP
FHA APPROVED

LOCATION
PARK AVENUE
MILLTOWN MANOR
EAST GOSHEN
TOWNSHIP

DIRECTIONS
Route 3 to
Township Line Road
(Ellis Lane)
North to Park Avenue

Large lots, fully graded, landscaped and seeded, driveway for off street parking, asphalt tile or hardwood floors, tiled bath. Youngstown kitchen, Hot Point electric range, 52 gallon (10 year guarantee) electric hot water heater, fully insulated and weather stripped, screens and screen doors, newest heating development, oil fired. Perimeter warm-air radiant heat. Provides warm, flexible, low-cost heat. Floors are always warm . . . no maintenance problems or expensive repairs.

CHESTER COUNTY BUILDERS, INC., BUILDERS
SALES REPRESENTATIVE
HARRY F. TAYLOR
13 NORTH HIGH STREET
WEST CHESTER, PA. PHONE 0299

SAMPLE HOME
OPEN
2 P. M. to 9 P. M.

FURNISHED BY
CURIOSITY SHOP
WEST CHESTER, PA.

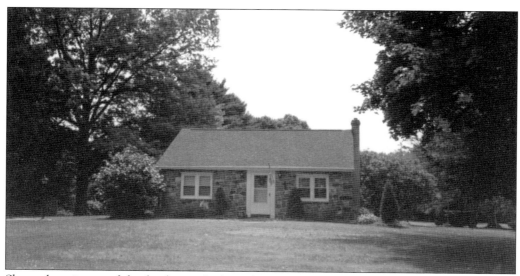

Shown here is one of the few homes built in the 1950s on Highland Avenue that has not been enlarged or significantly changed over the years. It is similar to the homes built on Park Avenue in Milltown Manor, which were also developed by Harry F. Taylor. (East Goshen Township.)

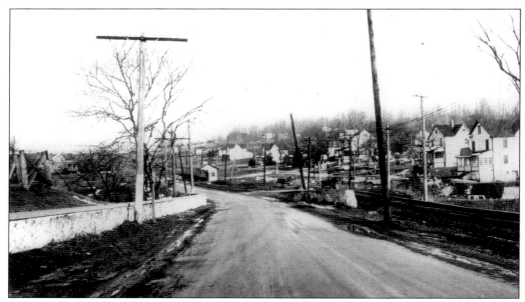

This photograph shows West Chester Pike looking east from Reservoir Road in the 1930s. On the right is the neighborhood of Goshen Heights and the trolley tracks. The photograph originally appeared in the book *The Red Arrow*, by Ronald DeGraw, published by Haverford Press in 1972. (Richard Neff.)

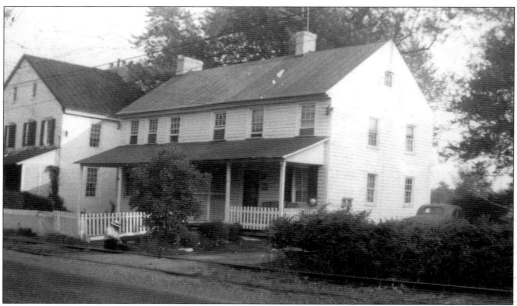

This home of T. Hartley Harrison Sr. was originally located at 1332 West Chester Pike. This photograph was taken in the late 1940s when West Chester Pike was a two-lane road and the trolley tracks ran along the south side of the street directly in front of the homes. The house was torn down in the early 1960s when the State of Pennsylvania widened West Chester Pike and removed the trolley tracks. (Ruth Ann Harrison Weeks.)

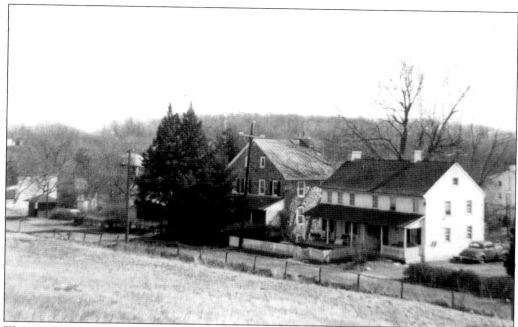

This is a photograph of the area known as Milltown on West Chester Pike in the 1940s. In the far left of the photograph is the small building that was the Milltown trolley stop. The houses were torn down in the 1960s when the road was widened. (Ruth Ann Harrison Weeks.)

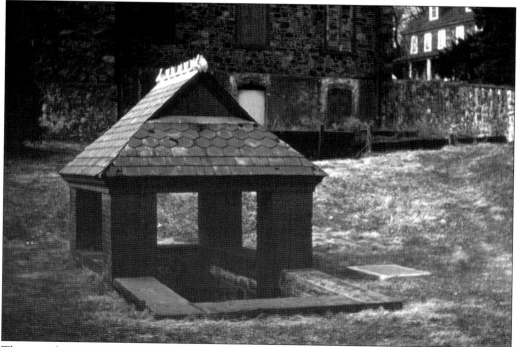

This is a photograph of the springhouse at the West Chester Water Works on West Chester Pike in 1960. It was torn down in 1960 when the road was widened. (Stephen Plummer.)

In the foreground of this 1960 photograph is the Pillsbury Mill on West Chester Pike. Both the mill and the house in the background were torn down when West Chester Pike was widened. They were located a short distance west of the West Chester Water Works. (Stephen Plummer.)

Seen here on West Chester Pike in 1958 from left to right are the Calvin Hull Upholstery Shop, George Velde's Goshen Dairy Bar, and the Thomas C. Supplee Farm Market. The upholstery shop is now a paint store. In 1960, William and Nancy Keslick purchased the dairy bar and operated it until 1973. The dairy bar and farm market have been replaced with a building for Firestone Tires. (William Keslick.)

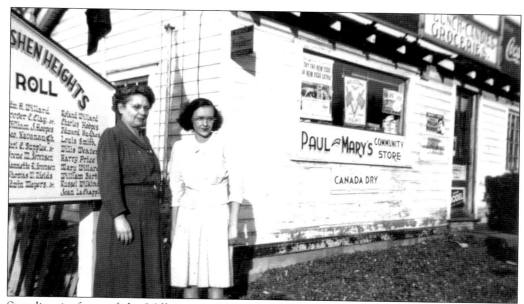

Standing in front of the Milltown and Goshen Heights Honor Roll plaque next to Paul and Mary's Community Store on West Chester Pike from left to right are Mary Engstfeld and Dorothy Grunwell in 1946. During World War II, the residents of Milltown and Goshen Heights erected this plaque to honor the neighborhood men serving in the military. (Stephen Plummer.)

A popular hangout for the boys of Goshen Heights was Paul and Mary's Community Store located next to the Milltown Garage on West Chester Pike. Shown here at the store in 1955 from left to right are (first row) Wayne Grunwell and John Bishop; (second row) John Phillips, George Davis, Thomas Supplee, and Stephen Plummer. (Stephen Plummer.)

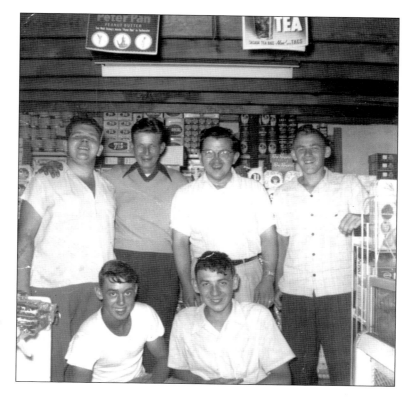

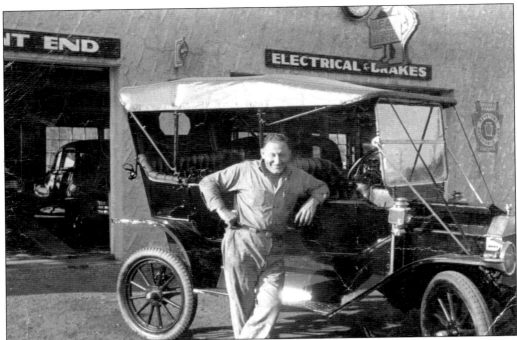

Shown here in 1949 is Fred LaChapelle with his 1919 Model T Ford in front of the Milltown Garage on West Chester Pike. (Robert Stafford.)

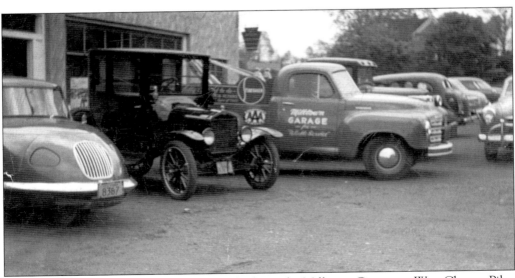

This 1949 photograph shows some of the vehicles at the Milltown Garage on West Chester Pike. On the far left is a Davis, which was a three-wheeled car. Next to it is a 1919 Model T Ford and the Milltown Garage 1947 Studebaker pickup truck. (Robert Stafford.)

In 1930, the Skyhaven Airport was opened on 85 acres of land owned by Samuel, Harry, and John Taylor. The runway was located where Highland Avenue is today. The airport operated until December 17, 1932, when Judge W. Butler Windle issued a permanent injunction to restrain the operation. The ruling came as a result of a complaint filed by several neighboring property owners and the Rush Hospital for Consumptives, which now operates as the Bryn Mawr Rehabilitation Center. (Phyllis Marron.)

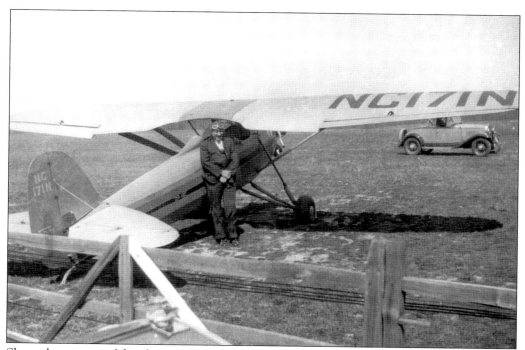

Shown here is one of the planes with an unidentified pilot that flew out of the Skyhaven Airport. (Phyllis Marron.)

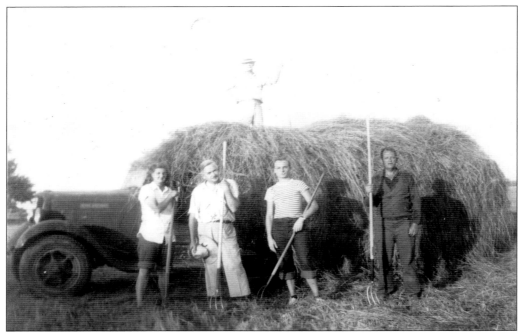

During World War II, hay was gathered by hand on the farm that is now the White Chimneys housing development. Shown here from left to right are Peggy Supplee Sepella, Earl Supplee Sr., Earl Supplee Jr., and Ted Supplee. (Ruth Ann Harrison Weeks.)

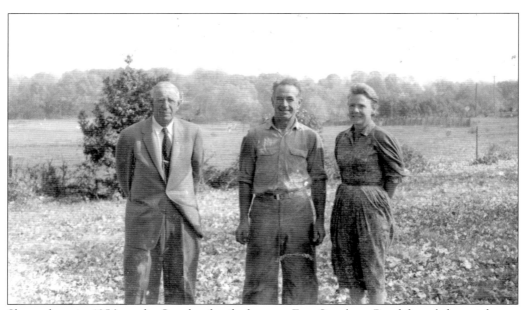

Shown here in 1956 on the Supplee family farm on East Strasburg Road from left to right are Chester Supplee, Wilmer Supplee, and his wife Bertha Supplee. Wilmer Supplee was active in the Goshen Fire Company and served on the board of trustees beginning in 1956. (Sarah Credeur.)

Shown here in June 1946 on the White Chimneys farm from left to right are Ruth Plummer, Florence Hartshorne, Earl Supplee, and Stephen Plummer with the filly Flicka. (Stephen Plummer.)

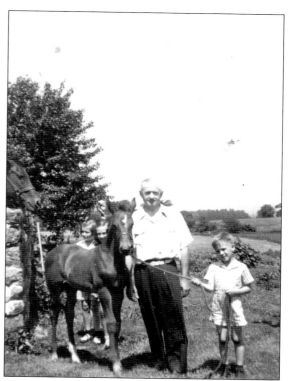

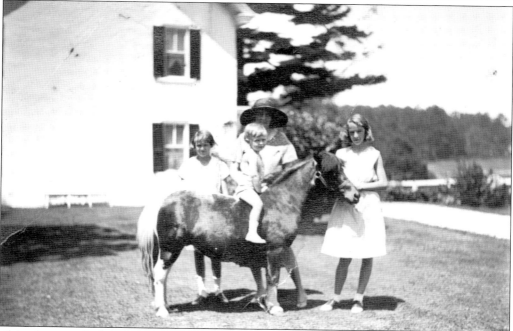

This photograph from 1933 is of Saunders Dixon on a pony in front of his home on Line Road. Pictured from left to right are Dixon's sister Elisabeth, his mother, Florence Dixon, and unidentified. (Saunders Dixon.)

BEER ON TAP

•

DINE AND DANCE

AT

THE ARCADE

MIDDLETOWN ROAD & PAOLI PIKE

GOSHENVILLE, PA.

PHONE WEST CHESTER 2282

Shown here is a 1934 business card from the Arcade Dance Hall located just south of Paoli Pike on Route 352, which was then call Middletown Road. In 1946, it became Melody Hall, and today it is the Pepper Mill Restaurant. (Saunders Dixon.)

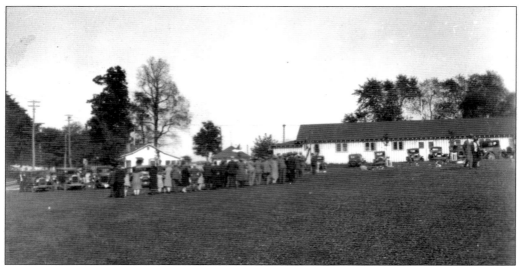

This 1930 photograph shows Melody Hall on the right and a gasoline station on the left. Located south of the intersection of Route 352 and Paoli Pike, Melody Hall was originally built in the 1920s by Phillip Harmon as the Arcade Dance Hall. The name was changed in 1946 to Melody Hall. It has been a dance hall, a roller rink, and the Melody Hall Store (similar to today's convenience stores). In 1977, the store was converted into a restaurant by Nicholas Fina. Today it is the Pepper Mill Restaurant. (Carroll Sinquett.)

This late-1920s photograph shows the Cornwallis house and barn located on Route 352 in the distance. The barn was demolished sometime between the time this photograph was taken and 1933, as it does not appear on the 1933 Franklin Survey Atlas. (Carroll Sinquett.)

The fire truck shown here in 1957 at the corner of Reservoir Road and Paoli Pike was built by the Robert Wiggins Fuel Oil Truck Company, which was located on West Chester Pike and Reservoir Road. It was built on a 1954 International chassis. The fields in the background are now the site of the Goshen Corporate Park. (Stephen Plummer.)

This house was built by George Farra in 1905 and was located on Route 352 where Atlee Drive is today. It was the home of Elmer and Mable Farra from 1939 to 1965. It was torn down in the early 1970s. (Phyllis Marron.)

Shown here in the 1950s from left to right are Mabel and Elmer Farra with their dog Wrinky at their home on Route 352. The house was torn down in the 1970s. (Phyllis Marron.)

In this November 1952 photograph from left to right are Dr. Norley and Wesley E. Boyles as they prepare to hunt pheasant in the fields along North Chester Road. Boyles served as a township road supervisor from 1949 to 1959. (Phyllis Marron.)

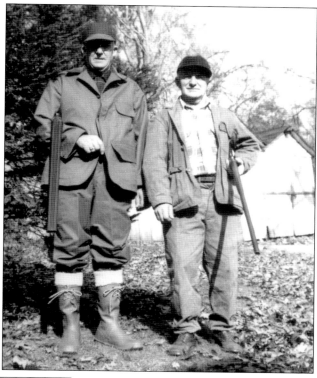

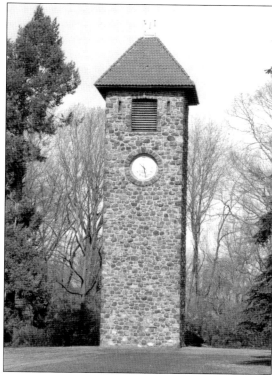

The clock tower, located on the property of the Clock Tower House on East Boot Road, was built in 1922 by A. S. Logan. It stands about six stories high. The date stone reads, "He designed this tower and dedicated it to peace." (East Goshen Township.)

This photograph shows the area that became what is today the Milltown Reservoir. It was taken in 1923 looking north from West Chester Pike. Reservoir Road is on the upper left portion of the photograph. (East Goshen Township.)

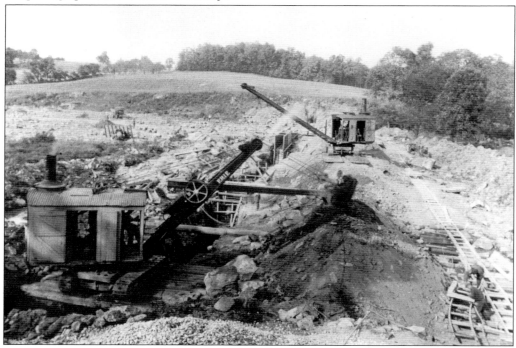

Pictured in 1923, the steam shovels are digging the area that would become the Milltown Reservoir. (East Goshen Township.)

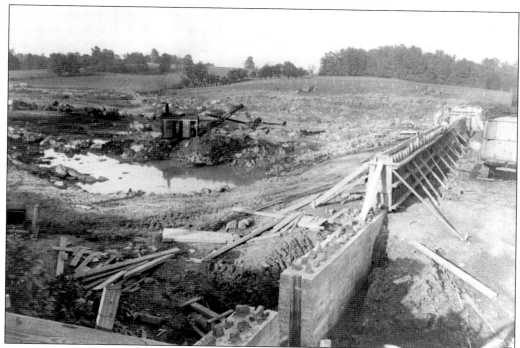

This photograph was taken in 1923 and shows beginning construction of the dam breast for the Milltown Reservoir. (East Goshen Township.)

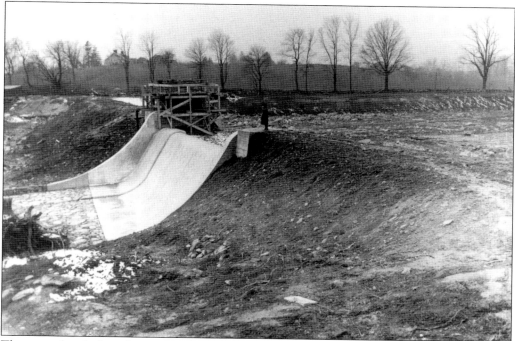

The completed dam breast at the Milltown Reservoir is pictured here in 1923. (East Goshen Township.)

This photograph of Reservoir Road was taken in April 1923 prior to the construction of the Milltown Reservoir. The Milltown Reservoir was constructed on the land on the right. (East Goshen Township.)

East Strasburg Road looking west to the intersection of Reservoir Road is pictured here in April 1923. (East Goshen Township.)

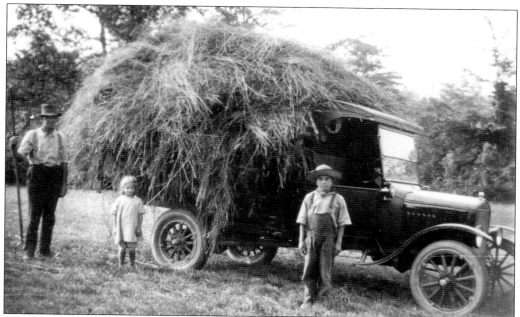

This 1926 photograph of the Jones family was taken on the Ashbridge farm on East Strasburg Road when the property was owned by Howard E. Jones. The 198 acres remained mostly intact until 2002 when the property was subdivided into 11 residential home sites with a minimum of 10 acres and a 55-acre nature preserve. (Mae Schmitt.)

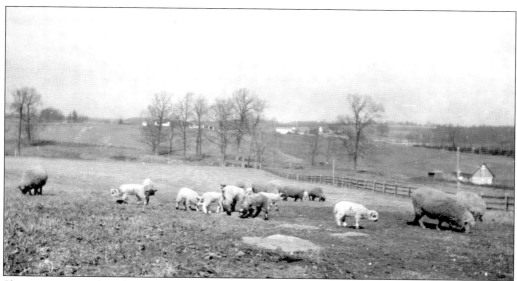

Sheep once grazed on farms along West Chester Pike. This photograph was taken looking north from West Chester Pike where the Goshen Meadows apartment buildings are located today. (Louis F. Smith.)

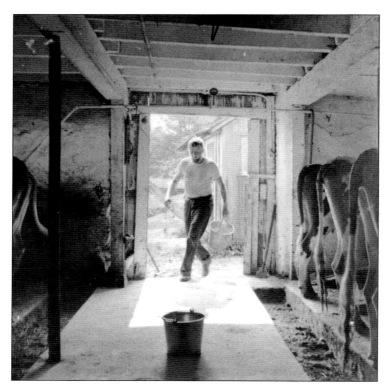

Here in 1958, Saunders Dixon is getting ready to milk the cows on his farm, which is located on Line Road and East Boot Road. Shown in this photograph is the old stone barn that burned in 1971. Today much of the farmland has been sold for a housing development, but Dixon still retains more than 30 acres for the Thorncroft Therapeutic Horseback Riding Center. (Saunders Dixon.)

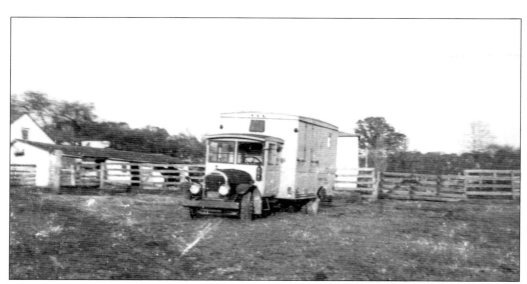

This photograph was taken in the 1930s and shows the 1926 Brockway horse trailer used by Dixon on his farm at Line Road and East Boot Road. (Saunders Dixon.)

Howard Slattery is planting a victory garden on his property located on Paoli Pike. The fields behind him belonged to Allen Young and became the housing development of Vista Farms in the 1960s. This photograph was taken in 1942. (Lois Cahaley.)

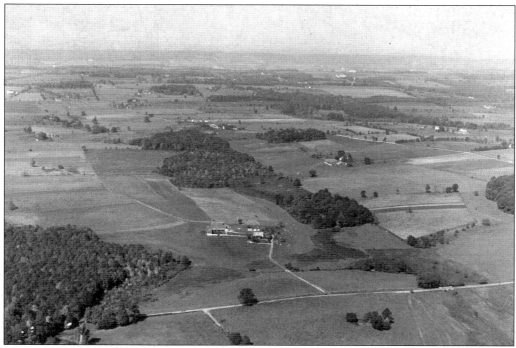

Shown here is a 1928 aerial view of the Hicks farm looking north with Paoli Pike in the foreground. (Ira Hicks family.)

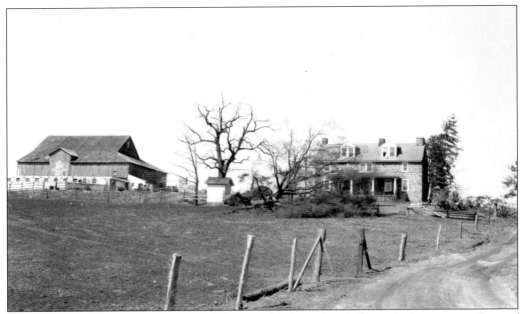

On March 22, 1955, a tornado traveled along Paoli Pike and took down the large tree in front of the home of Ira Hicks. There was no damage to the house. (Ira Hicks family.)

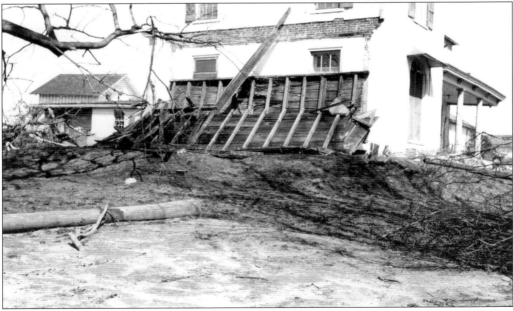

The March 22, 1955, tornado continued down Paoli Pike and tore off part of Russell Hicks's house and damaged his barn. (Ira Hicks family.)

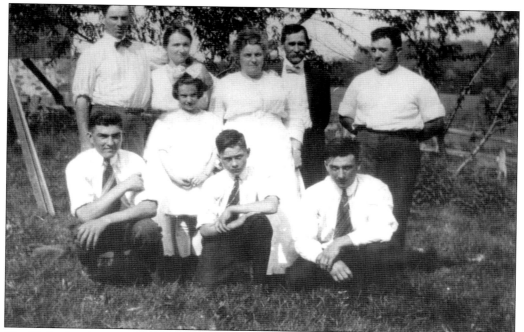

The Hicks family is pictured here in 1914. From left to right are (first row) Russell Hicks, Rachel Hicks, Ira Hicks, and Leroy Hicks; (second row) Charles Hicks, Alice Hicks, Anna Pratt Hicks, William Huey Hicks, and Earle Hicks. (Ira Hicks family.)

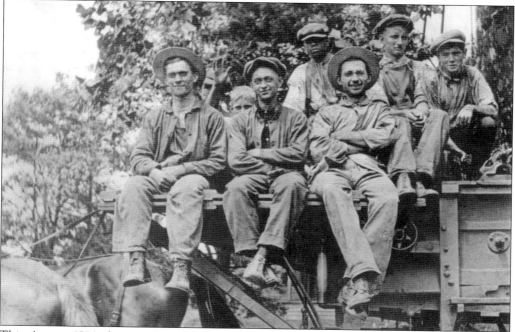

This August 1914 photograph of itinerant workers was taken on the Hicks farm. They went from farm to farm in East Goshen Township working the fields to bring in the crops. (Ira Hicks family.)

This photograph from the 1950s is of the barn and dairy cows on the Hicks farm on Paoli Pike. (Ira Hicks family.)

Shown here in 1942 are Ira Hicks and his horse Dazzler on his farm on Paoli Pike. (Ira Hicks family.)

Marjorie Henderson Buell, who is the author of the Little Lulu cartoons, is photographed here seated on the ground with her parents and sisters in May 1913. Her sisters Dorothy (left) and Betty (right) are seated on their parents' laps. The parents are Bertha Brown Henderson (left) and Horace Lyman Henderson. Buell lived on Hershey's Mill Road at the time her cartoons were being published. (Patricia Clark Youngblood.)

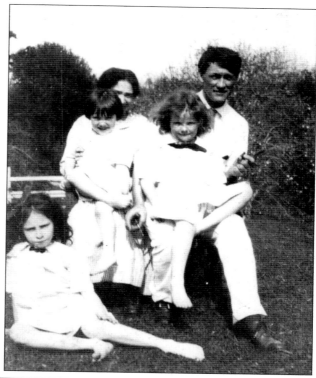

This book, published by McLoughlin Brothers, was given to Tanya Youngblood (Buell's grand-niece). Youngblood's grandmother was Buell's sister Betty Henderson Clark, who owned the farm next to Buell's on Hershey's Mill Road. (Patricia Clark Youngblood.)

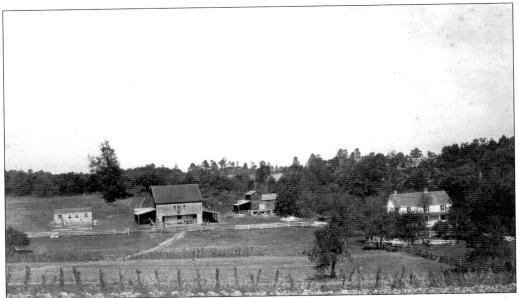

This 1913 photograph shows the Hershey's Mill Road farm of Lawrence E. Brown, the grandfather of Marjorie Henderson Buell. The date stone under the eaves of the house reads 1733 with the initials L. E. A., thought to be for members of Rudolph Lapp's family, the original builder of the house. (Patricia Clark Youngblood.)

This is the former home of Buell, located on Hershey's Mill Road. The house is an American foursquare house built in 1911 or 1912. The American foursquare style is basically a square, two-and-a-half story house with a center dormer and a large front porch. (East Goshen Township.)

Four

THE SUBURBAN YEARS

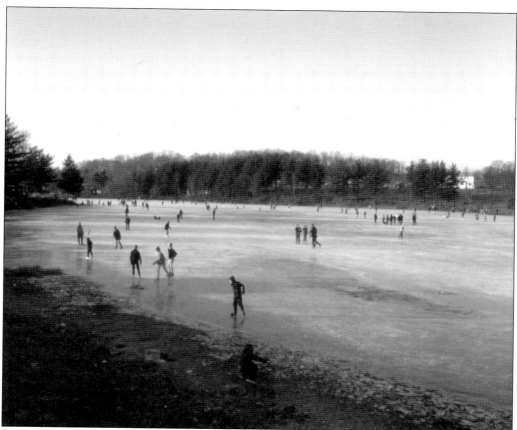

In 1969, a popular winter pastime was ice-skating on the Milltown Reservoir. (Jack and Kathryn Yahraes.)

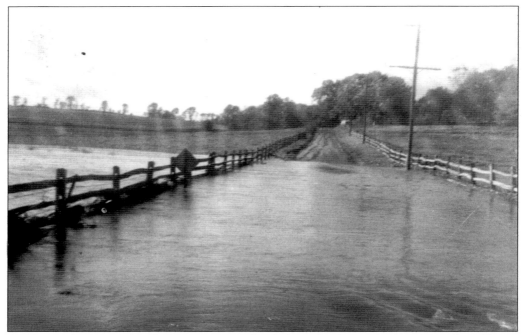

On September 12, 1960, Hurricane Donna flooded much of East Goshen Township. Shown here is Reservoir Road looking north from East Strasburg Road near the bridge that crosses the Chester Creek. (Sarah Credeur.)

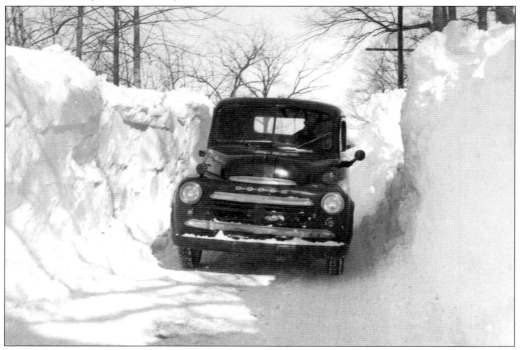

Shown here is Saunders Dixon's truck coming down Line Road after a snowstorm in February 1961. (Saunders Dixon.)

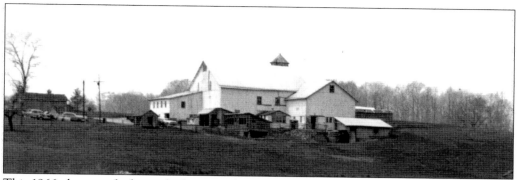

This 1966 photograph shows the barn on the Supplee family farm on East Strasburg Road that burned down in 1972. (Sarah Credeur.)

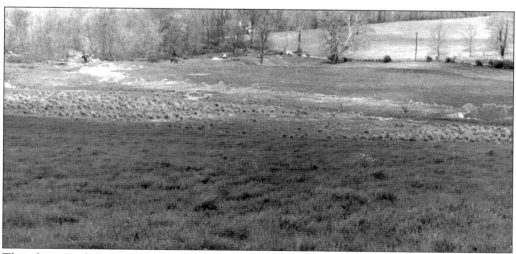

This photograph from the late 1960s is of the Supplee farm on East Strasburg Road looking east toward Cooper Circle and Reservoir Road. The area is currently part of township-owned open space where native wetland plants have naturalized the area. (Sarah Credeur.)

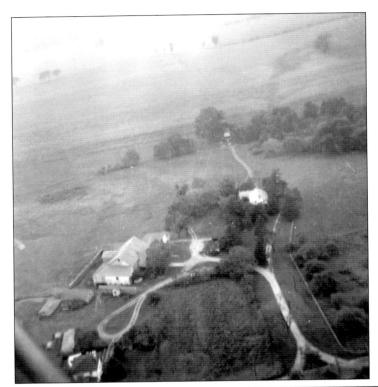

Shown here is an aerial view taken in the late 1970s of the Thorncroft farm on Line Road and East Boot Road. Today the Hunt Country housing development occupies the fields at the top of the photograph. (Saunders Dixon.)

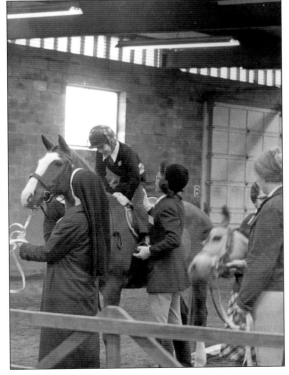

Shown in this photograph is a student getting instruction at the Thorncroft Therapeutic Horseback Riding Center on Line Road and East Boot Road. Established in 1971, Thorncroft specializes in therapeutic horseback riding for mentally, emotionally, and physically challenged children and adults. Thorncroft is a not-for-profit organization with 30 full- and part-time staff and 40 horses. (Saunders Dixon.)

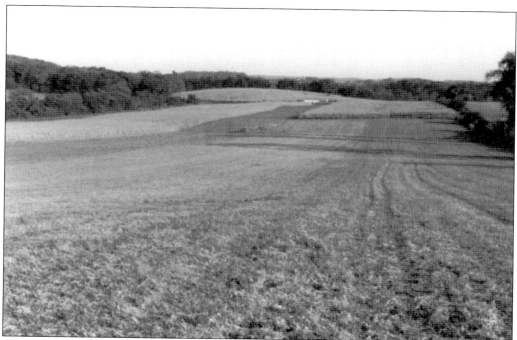

Shown here in the late 1970s is Saunders Dixon's farmland where the Hunt Country housing development was built. (Saunders Dixon.)

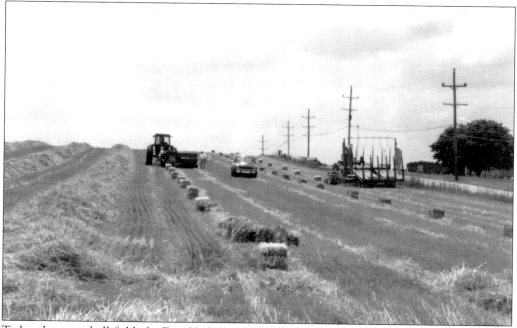

Today there are ball fields for East High School where this photograph was taken in 1970. The road on the right is Ellis Lane, and the field is planted with wheat. (Ira Hicks family.)

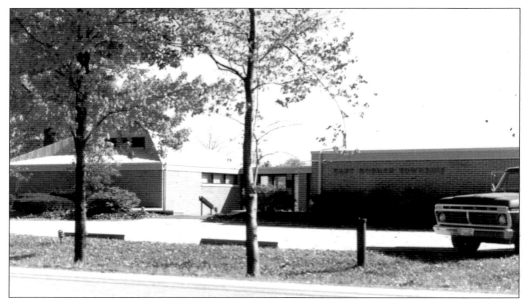

This photograph shows the first East Goshen Township building, which was built in 1968 on Paoli Pike. Prior to the construction of this building, Township meetings were held in rented office space. By early 1990, the township had outgrown the building, and in 1993, a new larger building was constructed on this same site and the original building demolished. (East Goshen Township.)

In 1980, Thomas Smith, a longtime resident of the township, was hired for the newly created position of township manager. The position was created because of the tremendous growth the township was experiencing at that time. He served in that capacity until 1986. (Margie Ferguson.)

By 1990, the township needs had outgrown the original building that was built in 1963. This photograph is of the new township building constructed in 1993 on the same site of the original building. (East Goshen Township.)

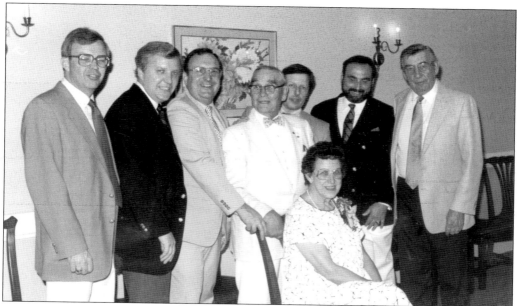

Seated at her retirement party in 1985 is Mae Schmitt. She was first appointed township secretary in 1949 and worked for the township until 1955 when she left for other employment. She returned in 1961 and served as both the township secretary and treasurer. Shown from left to right are Burgess Rhodes, Thomas Tawney, Martin Shane, Ira Hicks, John Chatley, Antonio Iacovelli, and Thomas Smith. (Margie Ferguson.)

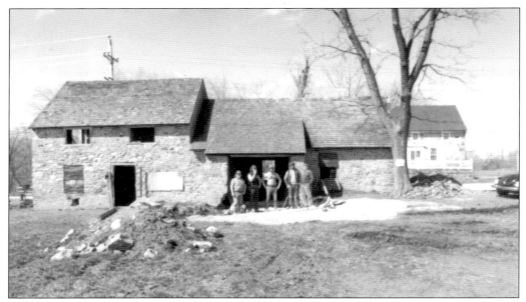

This photograph from 1982 shows the condition of the blacksmith shop as the workers began the restoration for the township tricentennial. Before the restoration began, cattle freely roamed the building, as the windows and doors had long since disappeared. Pictured from left to right are Ken Brown, Frank Smith, Randy Johnson, Rick Smith, and Ira Hicks. (East Goshen Township.)

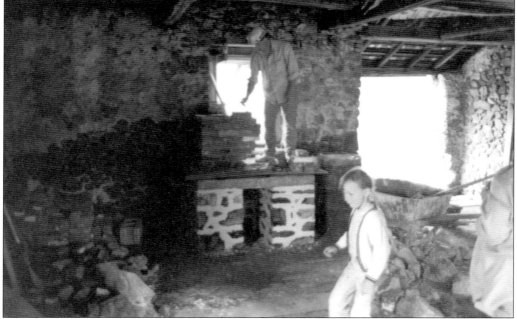

For the township's 300-year anniversary in 1982, major restoration work was done to the blacksmith shop on Route 352. Windows and doors were installed, a concrete subfloor poured, old barn flooring installed, and the hearth rebuilt. This photograph shows a young Tanya Youngblood in the foreground while her father, Charles Youngblood, rebuilds the chimney for the hearth. (East Goshen Township.)

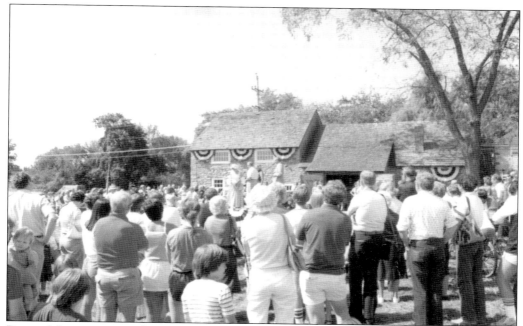

Pictured here are township residents at the dedication ceremony for the blacksmith shop on September 6, 1982, during the East Goshen Township tricentennial celebration. (East Goshen Township.)

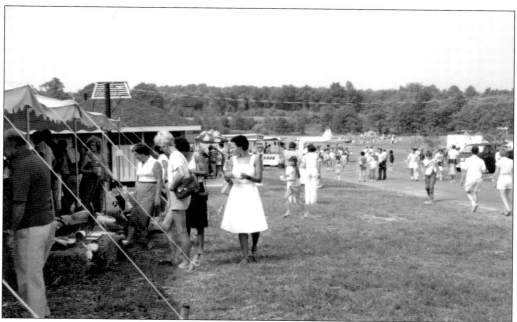

Shopping at the craft booths set up in the East Goshen Township Park was one of the many activities during the tricentennial celebration on September 11, 1982. (CCHS.)

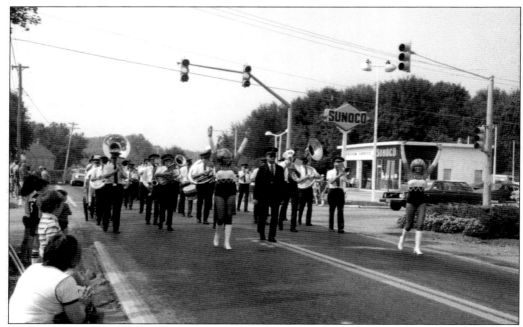

The Lukens Steel Band was one of several bands in the parade during the township's celebration of the tricentennial in September 1982. In this photograph, they are going east on Paoli Pike and crossing the intersection of Boot Road heading to the township park. (CCSH.)

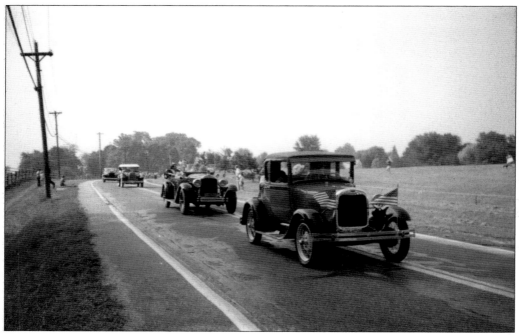

Seen here in the September 1982 tricentennial parade are antique automobiles. On the right of the photograph is the township park. (CCHS.)

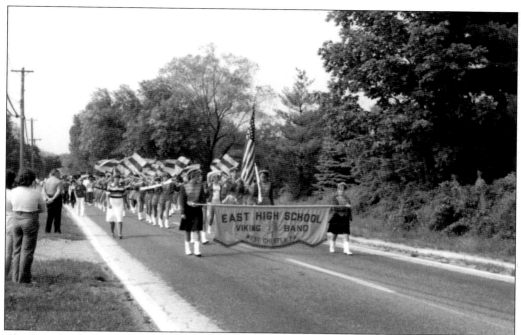

The East High School Viking Band participated in the September 11, 1982, tricentennial parade. East High School, which is located on Ellis Lane and Paoli Pike, services most of the East Goshen Township students. (CCHS.)

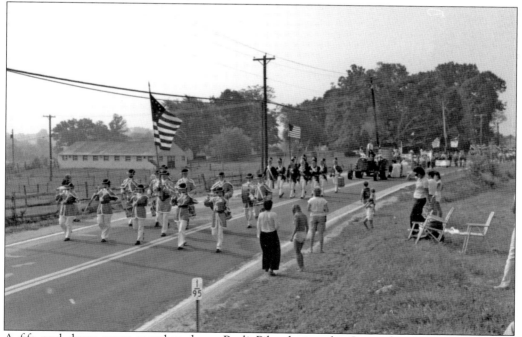

A fife and drum corps marches down Paoli Pike during the September 1982 tricentennial celebration. The parade began at East High School at Ellis Lane and Paoli Pike and ended at the East Goshen Township Park. (CCSH.)

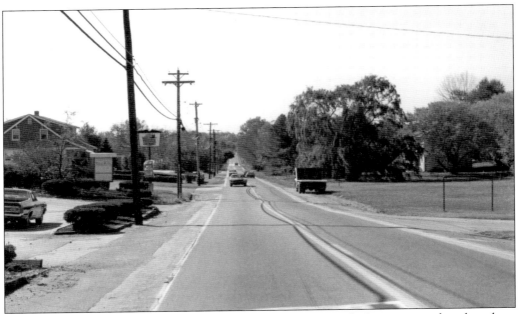

This is a photograph of Paoli Pike looking west, taken in 1982 before it was widened to three lanes. (John Chatley.)

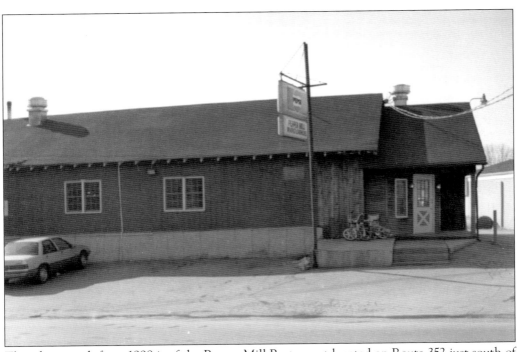

This photograph from 1998 is of the Pepper Mill Restaurant located on Route 352 just south of Paoli Pike. The building was originally the Arcade Dance Hall in the 1920s. It became the Pepper Mill in 1982 and is a popular eating place for East Goshen residents. (East Goshen Township.)

The southwest corner of Paoli Pike and Route 352 is shown here in the 1980s. There have been many gasoline stations at this location over the years. The first one was built in the late 1920s. Since then, there has been an Esso station, an Arco station, a Mobile station, and an independent station. Currently, there is a Swiss Farms drive-through milk store on the site. (East Goshen Township.)

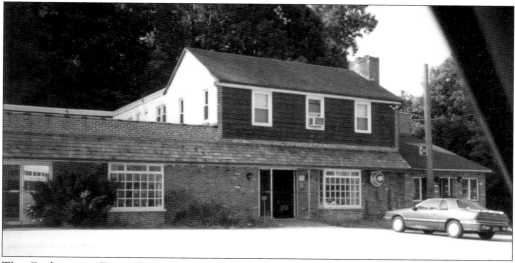

The Goshenview Dairy Store was originally located on the north side of Paoli Pike just east of Airport Road. The store sold milk in glass bottles and homemade ice cream from the Hicks family dairy farm. It opened in August 1966 and operated until 1999 when the property was sold and the building demolished. (Ira Hicks family.)

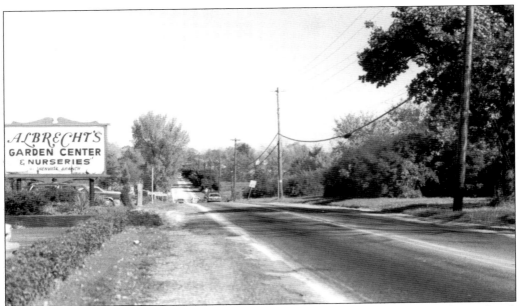

This 1982 photograph of Paoli Pike is a view looking east from the intersection of Boot Road. Today the CVS Pharmacy is located where Albrecht's Garden Center is, and the Goshen Village Shopping Center is across the street on the right side. The Wentworth housing development, which was built in the late 1980s, is located east of Albrecht's. (John Chatley.)

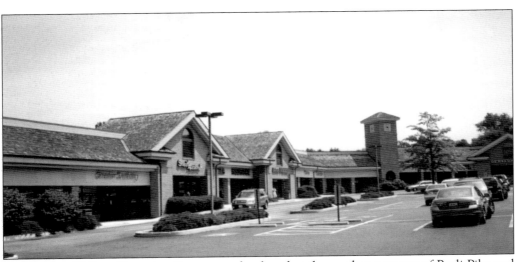

The Goshen Village Shopping Center was developed at the southeast corner of Paoli Pike and Boot Road in 1987. (East Goshen Township.)

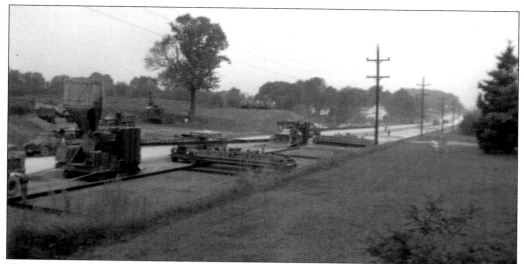

Shown here is the widening of West Chester Pike in the early 1960s. At that time, the trolley tracks that ran from Philadelphia to West Chester were removed. This view looks west from Reservoir Road. (Louis F. Smith.)

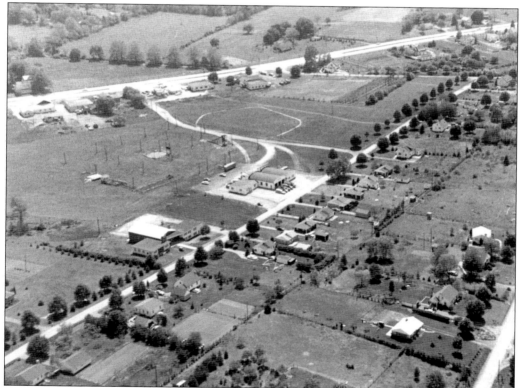

This is a 1963 aerial view of the area along Park Avenue and West Chester Pike. In the middle of the photograph is the Goshen Fire Company on Park Avenue. In the upper portion of the photograph is West Chester Pike. Today the Goshen Professional Center is located where the farm fields are in the top of the photograph. (Robin Hutchinson.)

Bernard Hankin was a major developer in East Goshen Township. He was responsible for the development of New Kent Apartments and the housing developments of Mary Dell, Pin Oak, Clock Tower Farm, and Bow Tree. He built the sewer treatment plant in 1980 and donated it to the township. He was considered a man of his word who built quality homes. (Hankin Group.)

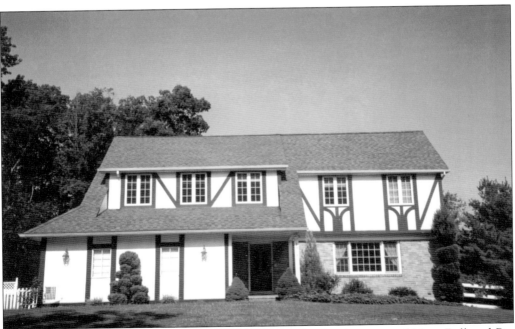

This Tudor-style home was built in the early 1970s in the developments of Mary Dell and Pin Oak, which are located on the west side of Route 352. (East Goshen Township.)

The Bow Tree development of 338 homes on Route 352 was built in three phases beginning in 1985. The homes in phase one were built by three different builders, giving that part of the development a different style than is found in phases two and three, which were built by one builder, Ferguson and Flynn. This house is from phase one of the development. (Margie Ferguson.)

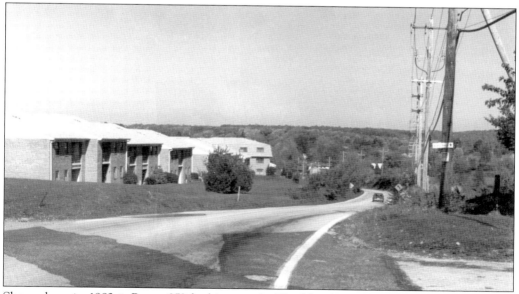

Shown here in 1982 is Route 352 looking north. The New Kent Apartments are on the left. They were built in 1974 by the Hankin Group. It was one of the first apartment complexes built in the township. (John Chatley.)

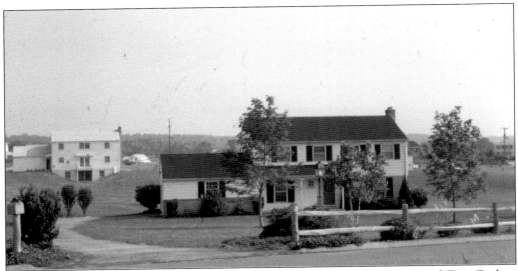

This 1966 photograph is of a typical Colonial house found in Vista Farms and East Goshen Township. At the time this photograph was taken, the house was six years old. As with most of the housing developments in the township, the land had previously been a farm, and there were few trees. (Jack and Kathryn Yahraes.)

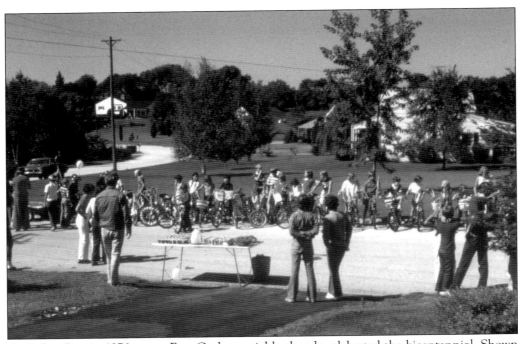

On Labor Day in 1976, many East Goshen neighborhoods celebrated the bicentennial. Shown here are the children in Vista Farms ready to parade through the neighborhood on their decorated bicycles. (Jack and Kathryn Yahraes.)

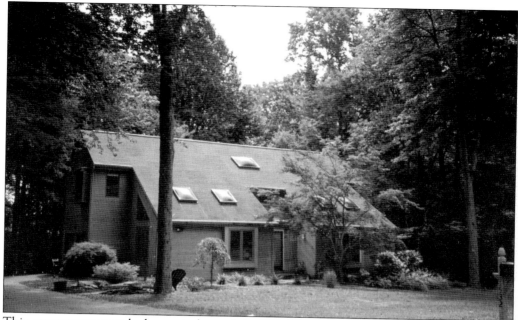

This contemporary-style home is located in Hershey's Mill Estates and was built in the mid-1980s. Hershey's Mill Estates and Fairway Village are the only housing developments where contemporary-style homes were built. (East Goshen Township.)

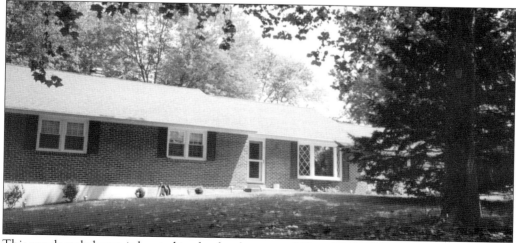

This ranch-style home is located in the development of Grand Oak on Boot Road and was built in the late 1960s. (East Goshen Township.)

This photograph was taken in 1982 and shows Route 352 looking south from the intersection of Boot Road. Today the development of Bow Tree is located on the land seen at left. (John Chatley.)

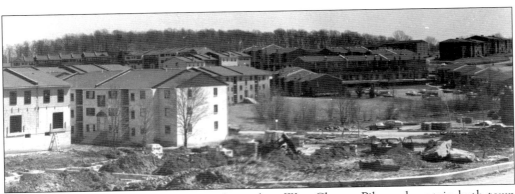

The Goshen Valley Condominiums are located on West Chester Pike and contain both town houses and apartments. They were built in three phases and consist of 686 units. This photograph shows the construction of the final phase, which was completed in 1985. (Margie Ferguson.)

This advertisement for the Waterview Apartments on West Chester Pike ran in the *Philadelphia Inquirer* in June 1968. (East Goshen Township.)

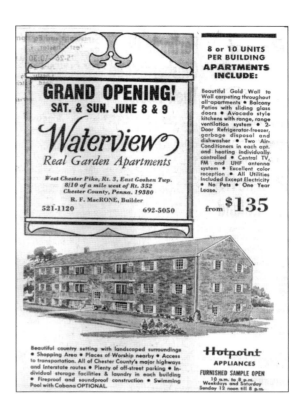

Opened in 1990, the Bellingham Retirement Community was built on East Boot Road on what was once the farm of Joseph Garrett in the 1700s. The original 1720s farmhouse on the right in the photograph is now the clubhouse, and the 1780s bank barn was converted into the dining hall for the residents. (East Goshen Township.)

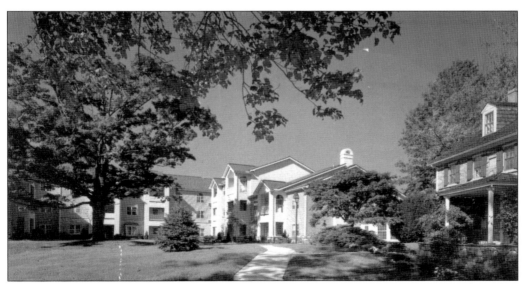

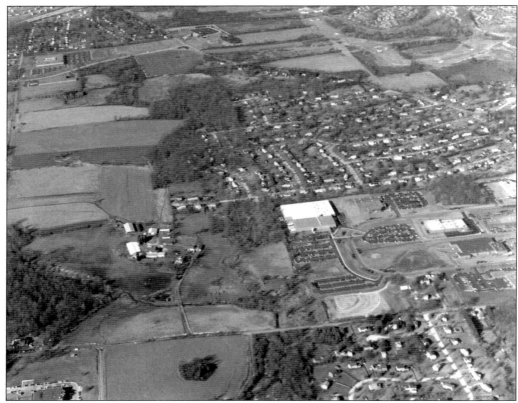

This 1989 aerial photograph shows the Hicks farm on Paoli Pike in the middle left. The Grand Oak housing development is in the upper right, and the Meadows housing development is in the bottom right. In the center right is the Goshen Corporate Park. The large building in the center was the headquarters of QVC. (Ira Hicks family.)

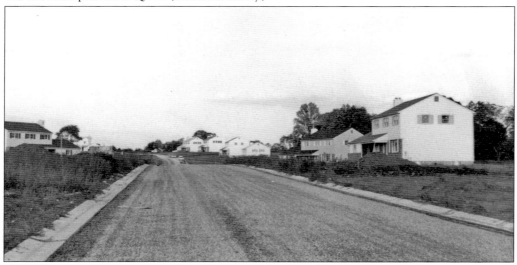

Shown here in 1966 are some of the first homes built in the development of Grand Oak Run, which is located on Boot Road north of Paoli Pike. (CCHS.)

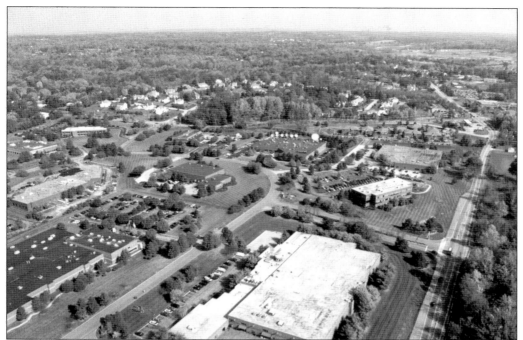

Here is an aerial view of the Goshen Corporate Park on Paoli Pike, which was built in the 1980s. (Louis F. Smith.)

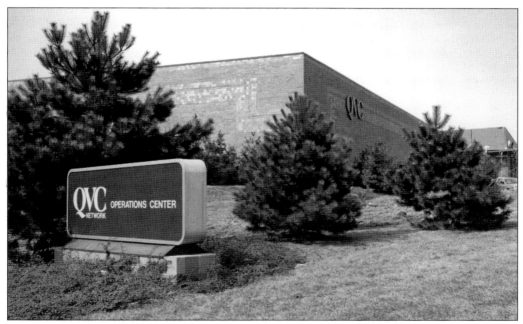

QVC, one of the world's largest multimedia retailers, launched its first television broadcast on November 24, 1986, from its original corporate headquarters in this building in the Goshen Corporate Park. QVC moved its headquarters to West Goshen Township in 1997. The East Goshen facility now primarily serves as one of QVC's call and distribution centers. (QVC.)

This is a 1982 photograph of Greenhill Road looking west from the intersection of Route 352. Today Hershey's Mill Village Adult Community is located on the left, and the housing development of Hershey's Mill Estates is on the right. (John Chatley.)

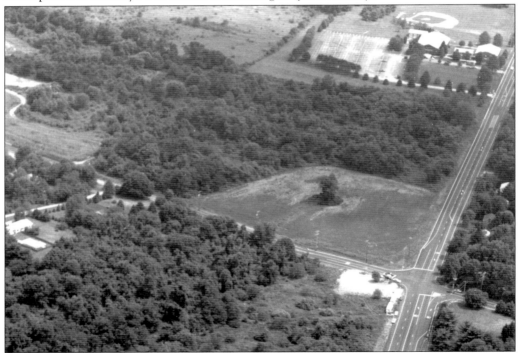

This photograph from August 1993 shows the intersection of Boot Road and Greenhill Road before the villages of Yardley and Troon were built in Hershey's Mill Village Adult Community. The buildings in the upper portion of the photograph are SS. Peter and Paul Catholic Church and school. (East Goshen Township.)

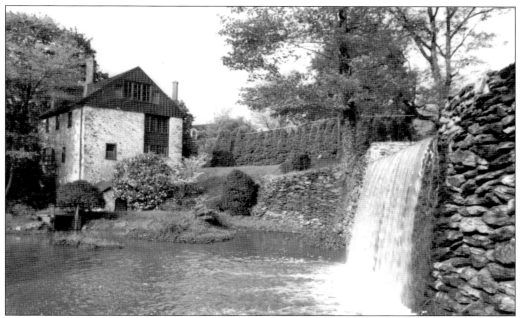

This photograph shows the Hershey's Mill and dam on Greenhill Road in 1982. Due to structural weakness in the dam breast and new environmental regulations, the dam may have to be breached or reconstructed in such a way that it will no longer look as it does in this photograph. (East Goshen Township.)

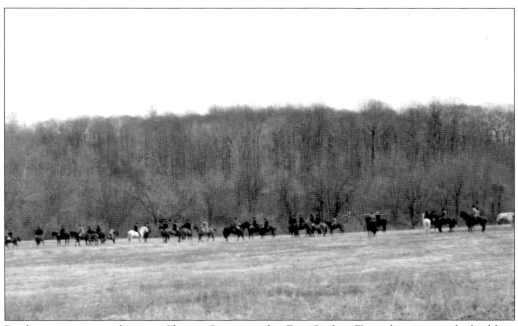

Fox hunting was a tradition in Chester County and in East Goshen Township prior to the building of houses on the farm fields. This photograph shows the Radnor Hunt sometime prior to 1970 on the property that became Hershey's Mill Village Adult Community. (East Goshen Township.)

Shown here is a house that was built around 1850 and is now located in Hershey's Mill Village Adult Community. It is named the Sullivan house for the last owner of the property when the land was a farm. Today it is available for use by the residents of Hershey's Mill for social functions. The building appears on the 1883 Breou Farm Atlas as being owned by Lawrence Hipple. (East Goshen Township.)

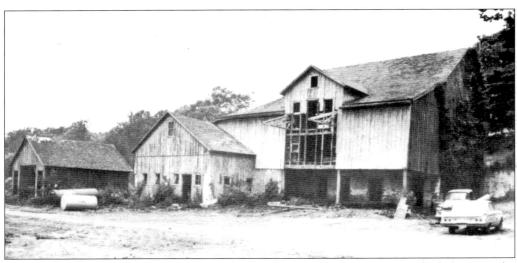

Shown here in 1972 is the barn that was located on the Sullivan tract, which became the Hershey's Mill Village Adult Community. It was demolished when Hershey's Mill was developed. (Raymond Freyberger.)

Shown here in October 1974 is Aston Village, which was one of the first villages built in Hershey's Mill Village Adult Community. Hershey's Mill covers 770 acres and includes an 18-hole golf course. Development continued into the 1990s. (East Goshen Township.)

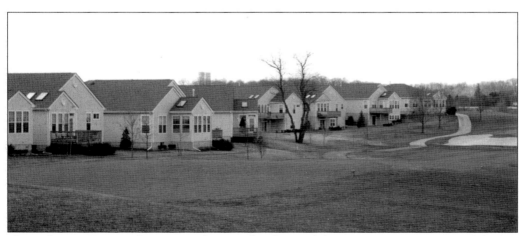

Shown here is Troon Village in Hershey's Mill Village Adult Community. It was one of the last sections to be developed and differs from other homes in Hershey's Mill. It consists of individual units built on zero lot lines versus town houses. (East Goshen Township.)

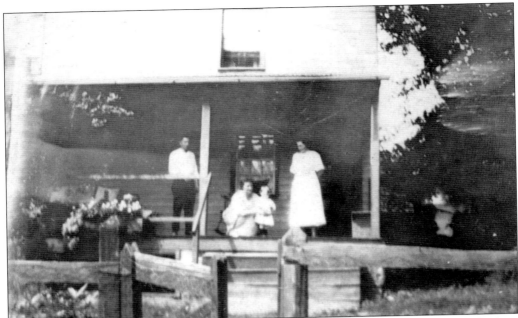

In 1845, Woodward Brown purchased the Milltown Hickman Plank house, which was built in 1808. Shown here on the front porch of the house in 1918, from left to right, are Frank Lytle, Mae Lytle, Joseph Nields, and Laura Brown Nields (great-granddaughter of Woodward Brown). The house remained in the Brown family until it was sold in 1983. (Edith Nields Green.)

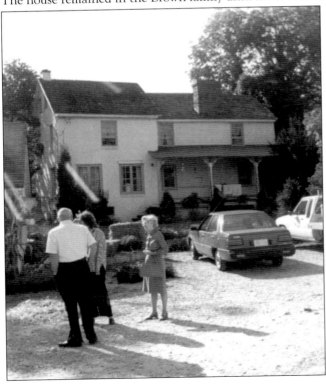

Shown here in 1989 is the Milltown Hickman Plank house, which was built by Benjamin Hickman Jr. It was located in Milltown on West Chester Pike and was going to be demolished. The house was listed on the Chester County Historic American Building Survey because of its plank construction. In the middle of this photograph is Edith Nields Green, who was born in the house. It remained in the Nields family from 1845 until 1986. (East Goshen Township.)

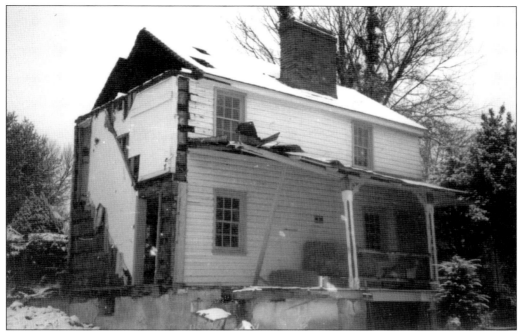

Shown here in 1989 is the Milltown Hickman Plank house being dismantled. Here the 1969 addition has been removed. The addition was not reconstructed when the house was rebuilt by East Goshen Township on East Boot Road. (East Goshen Township.)

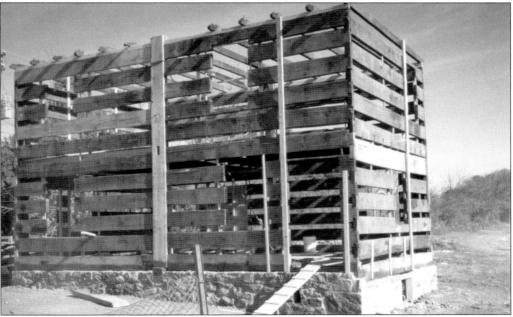

This photograph shows the Milltown Hickman Plank house in 1999 as it is being reconstructed on East Boot Road across from the East Goshen 1740s blacksmith shop. This photograph shows the 3-by-12-inch oak planks that form the frame construction of the house and give it its name. (East Goshen Township.)

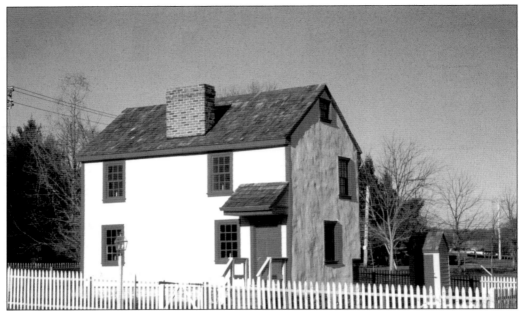

The Milltown Hickman Plank house restoration was completed in December 1999. It is owned and operated by East Goshen Township and is now a museum house open to the public. The house is furnished with period and reproduction furniture dating from the late 18th to the early 19th centuries. (East Goshen Township.)

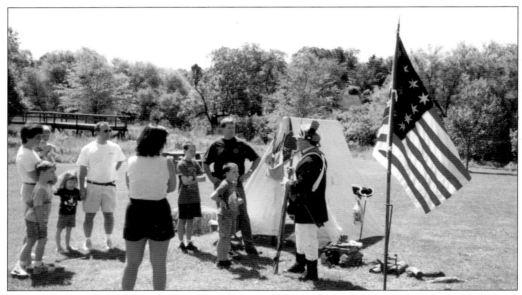

Living History Day has become an annual event at the township blacksmith shop and Milltown Hickman Plank house. Charles Lang from the 5th Pennsylvania Regiment tells the children about the lives of soldiers during the Revolutionary War at the 2001 event. In addition to reenactors there is Colonial cooking in the Milltown Hickman Plank house, a blacksmith working in the blacksmith shop, candle making, quill pen writing, and games for children. (East Goshen Township.)

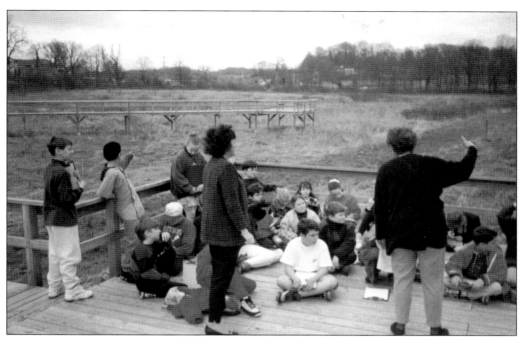

In 1994, East Goshen Township constructed a boardwalk through four acres of wetlands on Route 352 and East Boot Road. The area had been mowed for many years and in the 1970s was used as a cow pasture. In this photograph, children from the local elementary school learn about the importance of wetlands to the environment. (East Goshen Township.)

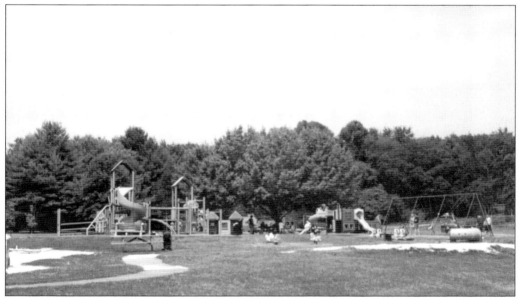

In 1955, East Goshen Township purchased 55 acres on the north side of Paoli Pike for a park. The park contains ball fields, tennis courts, basketball courts, soccer fields, and two pavilions with picnic tables. Shown in this photograph are families enjoying the tot lot. (East Goshen Township.)

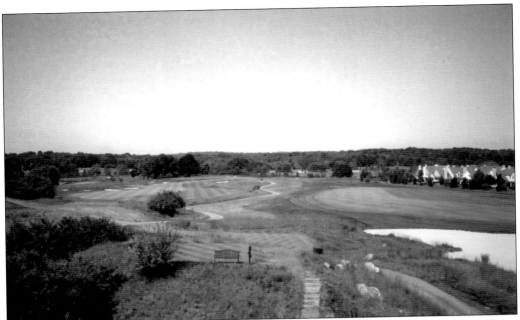

In 1999, East Goshen Township, Chester County, the Willistown Conservation Trust, Applebrook Associates, and Brandywine Realty Trust put together a plan to preserve the 311-acre Applebrook farm, which was owned by Pfizer, Inc. The plan included the 161-acre private Applebrook Golf Course shown here, a 100-acre township park, 12 single-family homes, and 64 carriage homes. (East Goshen Township.)

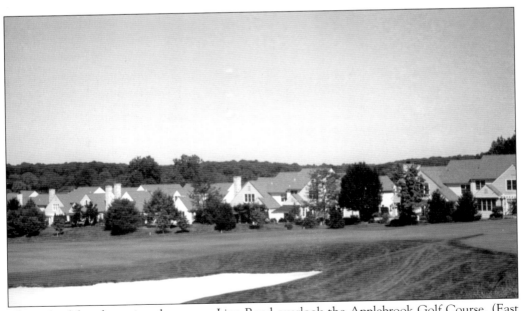

These Applebrook carriage homes on Line Road overlook the Applebrook Golf Course. (East Goshen Township.)

Purchased in 1999 and located on the south side of Paoli Pike is the 100-acre passive recreation area of the East Goshen Township Park. In the foreground of this photograph is the township parkland, and the Applebrook Golf Course and homes are along East Boot Road in the background. (East Goshen Township.)

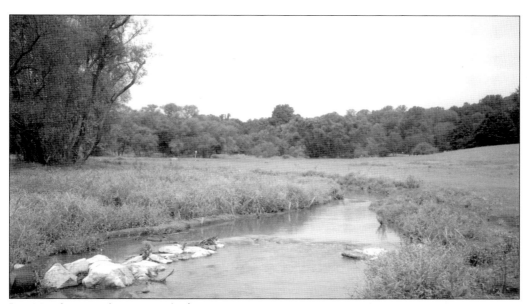

In 2001, the township received a $168,000 Growing Greener grant from Pennsylvania to restore 1,500 feet of the Chester Creek along Reservoir Road using the latest techniques for natural stream channel design. The above photograph shows a portion of the creek that was restored. Prior to the restoration, the stream banks were several feet high and severely eroded and the water quality of the stream was poor. (East Goshen Township.)

ACROSS AMERICA, PEOPLE ARE DISCOVERING SOMETHING WONDERFUL. *THEIR HERITAGE.*

Arcadia Publishing is the leading local history publisher in the United States. With more than 3,000 titles in print and hundreds of new titles released every year, Arcadia has extensive specialized experience chronicling the history of communities and celebrating America's hidden stories, bringing to life the people, places, and events from the past. To discover the history of other communities across the nation, please visit:

www.arcadiapublishing.com

Customized search tools allow you to find regional history books about the town where you grew up, the cities where your friends and family live, the town where your parents met, or even that retirement spot you've been dreaming about.